ALICE IRIS RED HORSE

ALICE IRIS RED HORSE

Selected Poems of

Yoshimasu Gozo

A BOOK IN AND
ON TRANSLATION

EDITED BY FORREST GANDER

Translated by Jeffrey Angles, Richard Arno,
Forrest Gander, Derek Gromadzki,
Sawako Nakayasu, Sayuri Okamoto,
Hiroaki Sato, Eric Selland, Colin Smith,
Jordan A. Yamaji Smith, Auston Stewart,
and Kyoko Yoshida

Interviews by Forrest Gander, Lee Yew Leong,
Aki Onda, and Akada Yasukazu

WUNDOR
Editions

First published in Great Britain in 2018 by Wundor Editions.
First published in the United States as New Directions Paperbook 1350 in 2016

Wundor Editions Ltd, 35B Fitzjohn's Avenue, London NW3 5JY

www.wundoreditions.com

Design – Rachel Ossip
Cover design – Matthew Smith

"Vision," by Adonis, translated by Anne Wade Minkowski, in Chants de Mihyar
le Damascène (Paris: Sindbad, 1983).

ISBN 978-0-9956541-7-4

Printed and bound by TJ International Ltd, Padstow, Cornwall

Contents

The Beyond of Gozo Yoshimasu

I first saw Gozo Yoshimasu read many years ago in Berlin. He began on his knees chanting in a whisper, not making eye contact with the audience. He was already absorbed into his performance. Already inside himself, present, but making contact with something else. His language was incantatory—the words barely audible. In fact, the sounds we were hearing weren't even always words. Gozo was breaking down Japanese language into phonemes, into counterpointed sonic progressions and rhymes. He was weaving into the mix fragments of English, French, Chinese, and Korean. If we in the audience had been able to look at the poem we were hearing him recite, we would have noticed not only the multiple languages, but the multiple scripts for writing them. He includes fragments of English, French, Chinese, Okinawan, and Korean, and he uses multiple scripts—Romanji, Korean Hungul, ruby annotations, and invented Man'yogana, and pictographs such as ☞ and ☜ , as well as normal Japanese kanji, hiragana, and katakana. Together, they function like stacked chords in a musical composition, creating harmonic complexes through which three or more melodic lines can be tracked. All of the text is rendered in an expressionist explosion of different colored inks.

Onto the floor of the stage, Gozo began to spread a collection of fetish objects. Not the beautiful little objects that Westerners often associate with Japanese art—netsuke or origami, for instance. Gozo's fetish objects were as common as a stapler, pebbles, a hammer. All the while that he chanted and rang a little sheep bell hanging from his neck, Gozo began to unroll a long copper scroll along the floor. The volume of his chanting increased.

On the fifteen-foot unrolled copper scroll, we in the audience could make out various engravings or seals. Over the course of several minutes, still sliding around on his knees, Gozo began to prepare an unmarked section of the scroll. In his left hand, he held a chisel over a blank section of the copper. He picked up the hammer with his right hand.

At some point, a French musician began to make wailing cat sounds on his guitar. Gozo repeatedly raised and lowered the hammer over the seal with the slow formality of a Noh actor. His voice changed pitch. His conjuration took on an ancient sonority, a sound that might have come from a time before the *Man'yoshu* formalized a common Japanese tongue, when traces of Chinese were more apparent in speech and etymology. He

seemed to be declaiming as though he were possessed. Of such moments in his readings, Gozo has said that his body harbors memories from early childhood when, strapped to his grandmother, he was exposed to kabuki and bunraku performances. He has said that in childhood, he suffered a kind of autism that made him hypersensitive to sound.

It isn't some romanticized originary language Gozo seeks, but a marriage of languages, he tells me, moving his hand in the air as though erasing a blackboard. In some sense, Gozo's poetry takes place before calligraphy, outside of language, but, as he says, "touching it."

It might be observed that this poetry has not been translated from the Japanese so much as it has been translated from Gozo Yoshimasu. And yet, as inflected as it is by visionary experience, by shamanism and an international avant-garde, Gozo's artistry, the clusters of motives connected by word play and literary precedence, *has* developed in the context of Japanese poetics, from forms as modern as yakuza slang (which works a bit like Cockney rhyming slang) and as old as the tanka.

———

Gozo's poems often explore, like Matsuo Basho's, moments in journeys that are at once physical and spiritual. Hence his trips to Hiroshima, to Namie (where a nuclear power plant meltdown contaminated the landscape), and to Rikuzentakata (where a tsunami permanently dislocated twenty thousand people and demolished every structure). As part of an ethical inclusiveness, he scrupulously cites the names of others with whom he shares conversations. Characteristically, he ceremonializes those references by citing dates and place names: "IN Kasumi, WITH Sato Masayoshi-san, last Year of the Rat—December 2009 – 31st, at three o'clock, just at year end...." He refers to friends and strangers and long-dead writers with tender reverence. Adonis is "that great poet of Dimashq (Damascus)." The Japanese filmmaker is "that Dear Ozu Yasujiro." Even a puppy is honored as "His Dogship." Gozo goes so far in his honorifics as to curiously dedicate someone else's poem, Hoshi Saigyo's twelfth-century "Furrowed Road of Embers," to a contemporary poet that he admires. It is critical for him to credit the words of others. Partly, he says, he does this out of shyness. He readily yields his own voice in order to allow for other voices.

Many poems are addressed to marginalized people—the Ainu of Japan, for instance—and to signal sites of presence and absence, to places from which people have disappeared. As Sayuri Okamoto points out, much of Gozo's writing, along with the films called *gozoCiné*, comprise the record of a never-ending conversation with the

dead. As though for Gozo all language, but especially poetry, is memorial. Since the 3-11 disaster in Japan, that complex of catastrophes—the earthquake, tsunami, and radiation leak that caused more than 20,000 deaths and forced the evacuation of 280,000 people—Gozo has felt called to "live as a poet." What this means for him is to cultivate a constant vulnerability, an ongoing receptiveness. It is an ethical stance.

What is missing from Gozo Yoshimasu's poetry on the page is about anything that resembles conventional poetry. Gozo's work sprawls, expanding and contracting like the universe. With side notes, multiple voices, repetitions, parentheses, super and minor scripts, with ruby—those small annotations that appear above base characters to indicate pronunciation—and quotations (often from 19th century American writers like Melville, Dickinson, and Emerson), Gozo's poems take on a Talmudic density. His focus on the letters and characters that make up words and his penchant for elaborate visual and aural rhymes, literary references, and narrative sketches might even seem, to the Western reader, cabbalic. But the poems aren't so intellectual or theory-generated as they are visceral, propelled by breath, the insistent pulses and vibrations, of the body in relation with a reciprocating world.

Undoubtedly, Gozo Yoshimasu is one of the most distinct, innovative, and influential poets of our time. It has been said that his poems are untranslateable. But all poems are untranslateable until the right translator shows up. Translation, in its many senses, is a constant theme in Gozo's writing, and because his work generates so many different reading experiences, the best way to share his poems with an English reading public may be through multiple translators, each approaching from a different angle. This would be in keeping with Gozo's own polyvocality and with the open-endedness of his body of work.

Some readers may question whether these innovative translations represent the original. But I wonder if the goal of "representing" the original is the goal of translation at all, given that the work is necessarily subjected to alteration, transformation, dislocation, and displacement. And given that transformation and displacement are major concerns in Gozo's work, maybe there are times when NOT "representing" the original is precisely what permits the creation of something less definitive but more ongoing, a form of translation that amplifies and renews the suppleness of the original poetry's meanings. Maybe there are times when the original doesn't function as any kind of definitive representation.

I've assembled a crack team of translators and encouraged them to bring Gozo into English by any means necessary. Derek Gromadzki has taken the notes written by those translators and subjected them to another kind of translation, drawing them closer to Gozo's poetry (and perhaps, in their metamorphic shift toward a more vertical

orientation, closer to an Asian axis). Derek's adaptations are viewable online at the New Directions website and constitute another dimension of this book's determined mutuality: in and on translation.

———

: BY FORREST GANDER

I.

Translator's Notes

––––––

This poem, beginning one of Yoshimasu's hallmark hybridized title-dedication-epigraphs, initially makes one feel not only that something is lost in translation, but that one is, oneself, somehow lost, wandering the realm of translation: both the translator and the editor of the present volume did a double-take at Yoshimasu's apparent dedication of another poet's poem to a third poet—but that is exactly what he did: Yoshimasu dedicates Saigyō's poem to Adonis (Adunis أدونيس). Saigyō Hoshi (1118-90) became a wandering monk at the age of twenty-two, lived in an era where the court nobility of the Heian period was overrun by a warrior culture in the Kamakura period, and spent significant time either atop mountains or writing of them. Any one of these biographical details provides context for Yoshimasu's poem built as a spiritual wandering over mountains, see(k)ing connections between human religiosity and the natural world. Saigyō was also an inspiration beyhind Basho's journeys to the northern areas of Honshū, referenced in Yoshimasu's "Naked Writing." Yoshimasu thus takes the notion of intertextuality, one embedded deeply in classical Japanese literature as *honkadori* 本歌取り or *honzetsu* 本説, and fixes them closer to the surface of the poem, as signs of exchange.

Connectivity becomes motif in this poem and calls attention to the translation at a number of points. The first word of the poem, translated "Typhoo**n**" with the *n* in bold , highlights Yoshimasu's unusual orthography: the Japanese word for typhoon is "*taifū*" (台風), but here the word is glossed with the pronunciation *taifūn*. As with many of Yoshimasu's wordplays, this "mystery *n*" leads to a crosslingual matrix. Affixing the Anglophone *n* underscores the word's sprawling etymological roots—with equal ground in the Greek *typhon* (whirlwind); in *tufān* of Arabic, Farsi, Hindi (storm); and in Sinophone languages, as above in Chinese and Japanese, as well as in the Korean 태풍 *taepung*. There is uncertainty surrounding its origins. The word merits both this translatorly explication as well as further critical analysis.

The poem's linguistic connectivity parallels other key moments of intertextuality. Yoshimasu quotes the French translations of two of Adonis's poems "Vision" and "Pierre" from *Aghânî Mihyâr al-dimashqî*, translated as *Chants de Mihyar le Damascène* (1961, tr. Anne Wade Minkowski). As the quotations appear in French amidst the Japanese text, they remain in French here. The first poem, "Vision," gives Yoshimasu the line "*drapé de feu*," describing a god whose arrival is awaited by Babelites in ritual garb:

火 · Fire

(To Adonis, — I dedicate the greatest poem of Saigyō Hōshi's life

———

Typhoon,——(Number three. July 7, 2000, Tanabata Festival, night // late, building to squall, but, hastily, passed through,...... while listening to its footfalls

Thinking of the fire in the heart of *Adonis*

«*drapé de feu*»

"soft flames of the earth's surface,... (July 8, 2000. From Miyake-jima, *like the hand of an infant*, // fresh some,oak (*smoke*,......) = hair,nothingness,village (ke毛,mu無,ri里,......)"

door = «戸»

seed of the fire even beyond the seed of the fire in the heart of *Adonis*-san

door = «戸»

(July 9, 2000. Hirasawa Yoshiko, eminent artist living in Paris, sent me,...... by that great poet of Dimashq (Damascus) / Adonis's "Stone (Pierre = 石)"—such beauty, such loveliness,......, the ti,ni,ness of "*pierre(ishi)*"......is, so that we can love it all the more tenderly

"*J'adore cette pierre paisible*"

(to Odaima Muhammed Abdullah-san and Takeda Asako-san, the day we went to ask about Adonis in Kodaira on the Ōme Kaidō Road, those rustling trees are unforgettable,......

door = «戸»

Unforgettable, Mount Qasioun in Damascus

Revêts-toi dun masque de bois brûlé	Don this mask of burnt wood
ô Babel des incendies et des mystères	Oh, Babel of infernos and of mysteries
J'attends un dieu qui viendra	I await a god who will come
drapé de feu	**draped in fire**
paré de perles volées au poumon de la mer	decked in pearls stolen from the sea's lungs
aux coquillages	and shells
J'attends un dieu qui hésite	I await a god who hesitates
fulmine, pleure, s'incline, rayonne	who rages, weeps, bends and shines
Ton visage, Mihyar	Your face, Mihyar
présage ce dieu à venir	Sign of the coming god
[emphasis added; my translation]	

Through this intertext and the metonymy in Yoshimasu's poem, *fire* becomes a versatile symbol for Babel, Adonis, the divine, the typhoon, and later, through Saigyō's poem, Mt. Fuji. Let us return to the importance of *fire* below.

Yoshimasu's poem also incorporates the first two lines of Adonis's poem, "Pierre," namely:

J'adore cette pierre paisible	I adore this peaceful rock
J'ai vu mon visage dans ses veinures	I saw my face amidst its grain

However, the third and final line—"*J'y ai vu ma poésie perdue*" ("I saw my lost poetry")—Yoshimasu leaves absent. The choice of "striped eye" makes little sense as a translation of the French "*veinure*" (veining, grain [as of wood]). Hirasawa's Japanese translation of the French translation of "Pierre" makes use of the Japanese word 縞目 (*shimame*: a slightly unusual word for "stripes" combining characters for stripes 縞, with that for eye 目). English translations of Adonis's poem typically emphasize the anthropomorphized features of the stone as well, so here I translate Hirasawa's word *hyperetymologically*: with obsessive attention to the component characters. These notes invite further analysis of the rich intertextual relationship between Adonis's poems and Yoshimasu's, and of the multiple layers of translation at work "between" authors that comprise, read across the *world* of world literature in its prismatic resistance to Babel.

The second major intertext comes at the end of the poem, when Yoshimasu cites Saigyō's untitled poem preserved in the *Shin Kokin Wakashū* (ca. 1439) anthology. I include the original, the romanization, and the translation so the reader may work through the layers of Yoshimasu's translingual homophony. The latter is centered around the character "火" (fire), which also stayed in the English title; Yoshimasu plays with

("mine eyes" that have seen the twinkling of another universe, were dreaming off, reading *The Quran*,"Have We (Allah) not made the land your cradle? (We made it so that humans may dwell peacefully there.) And made the mountains as stakes? (As stakes that bind fast the tent pitched in the desert. We have made the mountains firmly bind the earth and keep it from wobbling.)" Chapter 78, translated by Izutsu Toshihiko,......)

door = «戸»

Unforgettable, Miyake-jima fisherman on the verge of tears,—

(July 8, 2000, on the nightly news, truth told just wanna git outta here,......says the stammering fisherman's sun-browned drapé? "The heart's 火 · fire [fi(ə)r],......" is unforgettable,......

"*J'ai vu mon visage dans ses veinures* (I can see my face in the stone's striped eye)" (Translated by Hirasawa Yoshiko)

Adonis-san's mind's eye's fire's *ishi*'s striped eye/I feel I can also see it,

(Because, "I" has become the eye of the ɔhə,
"a purple bakke (bat) / Akiko-san," you see,......

door = «戸»

Nostalgia for Qasioun

Lovely mountain

(......, 's fire [fi(ə)r],...... "The Furrowed Road of Embers,"—. Saigyō Hōshi, lifetime greatest poem, let us dedicate to Adonis, —

Nostalgic Qasioun

door = «戸»

("風になびく富士のけぶりの空に消えてゆくへもしらぬわが思ひかな"
kaze-ni nabiku Fuji-no keburi-no sora-ni kieteyuku hemo shiranu waga omo**hi**-kana
"As the windblown smoke of Mt. Fuji disappears into the sky, so my oblivious **thought**s,"......

two pronunciations of 火 in Japanese (the standard *hi*, and the classical *ho*). This play encourages the reader to experience Japanese as a continuum of classical and modern modes, both at the linguistic and literary levels.

This translation similarly invites meditation on both Japanese and English as languages and literary bodies with historical depth and nodes of connectivity; I draw on words from Middle English as functional parallels of the older pronunciations Yoshimasu employs around the word 火. In this translation, the embedding of fossil words invites a variety of excavations. These include "fi(ə)r" (*fier*, of Middle English) for "fire," and "bakke" (Middle English) for "bat" (a previous edition of this translation used *flindermouse*).

As in "Naked Writing," this translation preserves Yoshimasu's homophonographic play. The construction "some,oak" ("sumo, oak" in the version in *Poetry Review*) allows words to emerge from the word *smoke*, a translation of the Japanese *kemuri*, from which Yoshimasu draws: *ke* 毛 (hair), *mu* 無 (nothingness), *ri* 里 (village).

Other kanji appear in the translation due to their aesthetic and semantic suggestiveness, prominently in the lines:

> door = «戸»
> door = «戸口»

戸 means "door" and sounds like "and." 口 means "mouth" and connotes an open entrance. Combined, 戸口 (*toguchi*) means "porch." Stacked vertically in the Japanese original, they also come to resemble the character 石 (*ishi*), meaning "rock," a word that also comes into play in this poem (as in Adonis's "Pierre").

This continues in the line: "I" has become the *eye* of the əhə. Here, Yoshimasu vamps on Hirasawa's word *shimame* (縞目). The character 目, pronounced *me* in Japanese, suggests "I" when Yoshimasu romanizes it as "me" (then turns the characters upside-down). The original 目-to-me conversion relies on a fortunate coincidence of the use of "me" as a first-person pronoun in Romance languages. It is even more fortunate that English provides the homophone I/eye, certainly one of the few examples of a shared double-entendre between Japanese and English.

Finally, a few references will be helpful. Tanabata (Qixi Festival in Chinese), the Star Festival of July 7, celebrates the once-a-year meeting in the sky of two divine lovers separated by the woman's father. The Quran references are variants of the lines, "Have we not made the earth a resting place? And the mountains as stakes?" from 78:6-7. Odaima Muhammed Abdullah is a scholar and translator living in Japan. "Akiko-san" refers to poet Yosano Akiko (1878-1942), renowned for her work in modernizing *tanka* poetry, a possible parallel to Adonis's work in Arabic poetry.

That emphasis on **hi** (Mr. Kubota Jyun), "feu" 火 [fi(ə)r]. So nostalgic, the hot 火 of "**hought**," so nostalgic, the <u>h</u>eat 火 of "**hi**", ——

———

: TRANSLATED BY JORDAN A. YAMAJI SMITH

Originally appeared in *Tokyo Poetry Journal*.

My thanks to the Babel translation society at UCLA, with its legacy of Michael Heim, where I presented an early draft of this translation, and especially to Efraín Kristal and Boris Dralyuk, who suggested important revisions.

Translator's Notes

————

Author's note: The text in small print was added on February 5, 2012, during a morning spent in the snow on the shores of Lake Red Castle (Akagi Ōnuma) [This lake is located in Gunma Prefecture, not far from the birthplace of Sakutarō Hagiwara, the famous poet evoked in the small annotations early in the poem. – *Translator's Note*]

This poem appeared in the daily newspaper *Asahi shinbun* as part of a series of poems by twelve of Japan's most prominent poets commemorating the one-year anniversary of the March 11, 2011, earthquake, tsunami, and nuclear meltdown. Many of the proper names are from the devastated regions of northeastern Japan. In particular, the Ishikari River is a place that impressed Yoshimasu deeply. Many years ago, he visited the snowy banks of the Ishikari River and was so impressed by the desolate landscape that he wrote the poem "Ishikari Sheets." Yoshimasu returned there after the earthquake to read this poem.

In many places in this poem, Yoshimasu plays with the associations between words, their sounds, and silence. For instance, in the comments accompanying this poem in the online version of the *Asahi shinbun*, he wrote that the symbol ツ represents the cessation of sound—a pause or silence within the poem itself. When following the sound oo, which is a bit like a short gasp, this silence might represent the moment in which a tear falls. Interestingly, Yoshimasu writes many of the sounds in kanji characters. This is relatively unusual in contemporary Japanese, which typically uses kanji to represent meaning rather than phonetics. For instance, the sound oo, is sometimes written with the character meaning "rabbit" (兎) and sometimes with the character signifying "universe" (宇), thus introducing another dimension of meaning into the poem.

Translation necessarily breaks certain sound-related connections; however, in rendering this poem in English, I have found that other connections and patterns naturally form, growing in new, idiosyncratic directions, like crystals growing from smaller molecular structures. The Korean and French inclusions appear as they did in the original text, with no corrections to the grammar.

at the side (côtés) of poetry

———

At the request of the online version of the *Asahi shinbun* and *Handbook of Contemporary Poetry*, I have written this poem on the theme "To the post-3.11 world, as I see it," but this is just the prelude. As day follows day, one step closes in upon another, one after the next, . . . at the root of language, one stitch, sewn together . . . that is how I have imagined my poetic production over the last year, —. The title will probably be just what it has been all along . . . This work will probably amount to a long work of approximately three thousand lines, . . . Thank you to the people in charge and to my readers. —February 6, 2012, in Ishikari

(a-ri-su) (ai, risu) (oh chūji, oh sakutarō, author of "ice land"! . . . there is ツ . . . cesium in red castle lake . . .)*
alice, iris, *red horse, red* castle, —
(ishi-su) (ishi – risu)
isis, stone, squirrel, *scent of ishikari,* —
 (oo ツ chūji, red castle lake, enormous, silence, . . . 950 becquerels, . . . oo ツ)*
oo (rabbit) ツ! oo (universe) ツ, *of enormous silence!* (oo ツ, *of Ukraina . . .*)*

 loup
loo, white wolf, from far away, faintly audible, the voice of reality, came to us, ,,
oo (rabbit) ツ! ([兎]토키 [t"ok'i: トキ]¶野~。 산~ [san~:サン]), ,, oo (rabbit) ツ!
 (huh?)
no, so—faint—ly? whispered voice, ,,,
oo (song) ツ! many! ツ! do not sing!
 ,,,,, (oo ツ, of Ukraina . . .)
"folding
 up
 the yellow springs of hades,"
 ishikari, ,,, (loup, hair raised, . . .)*

 loup
loo, white wolf, from far away, faintly audible, the voice of reality, came to us, ,,
in the shadows of the sand dunes of rikuzen takata . . .
. . . enormous, scraping hand, working

before the enemy, coming onland,

oo (universe) ツ！ ツ … ツ … ツ …

it took its bite, , , oo (rabbit) ツ！ *oo* (universe) ツ , *of enormous silence!* (oo ツ , *of* Ukraina …)*

(a-ri-su) (ai, risu)　　　　　　　　　　　　("ice land", sink to the bottom of the lake, old straw mats,

　　　　　　　　　　　　　　　　　　　two or three, 950 bequerels, sink to the bottom …)*

alice, iris, red horse, red castle,——

(ishi-su) (ishi – risu)　　　　　　　　　　(ka, ga, … rock-fish, mountain-woman, ツ ツ , ツ ツ genie

　　　　　　　　　　　　　　　　　　　of the (snake), …)*

isis, stone, squirrel, scent of ishikari,——

oo (rabbit) ツ！ *oo* (universe) ツ , *of enormous silence!* (oo ツ , universe, the deepest part, silent, …… oo ツ)*

loup
loo, white wolf, from far away, faintly audible, the voice of reality, came to us, , ,

kayakubo, kayakubo, …… (February 1, 2012, at 1:45 pm, in the deep mountains of Musashino)

kayakubo, kayakubo, …… (With y,o,u, so silent, hardly saying a thing)

kayakubo, kayakubo, …… (January 29, 2012, I was thinking of Marilya's, sound, from Paris,

　　　　　　　　　　　　　　　　　at my side)

kayakubo, kayakubo, …… (*Bonjour Marilya, Sooky nous a quittée à 15h. Elle n'est pas parti seul. J'étais*

　　　　　　　　　　　　　　　à ses côtés.)

the word *kote* meaning gauntlet, the word *côtés*, …… both, the audible *s* in *côtés*

= mu (nothingness), prick up your ears, to sound, , , ,

oo (rabbit) ツ！ ha, (ha ツ , …)

"folding

　　　　up

　　　　　　the yellow springs of hades, …… "

　　　　　　　　　　　　　　　　ishikari, , , , (loup, hair raised, …)*

(February 5, 2012, a call from Marilya in Europe, which is going through a cold spell, "I am glad I

can wear my Issey coat," she says, to Claude, ta, ka, ne, tara, both their hands. … faint caresses, are

approaching. … "côtés")

tententenmaritentemari(,)tententemarinotegatoreteNOte

to,u,ch,ing the mysterious form at the heart of the "s" (,) there, is, where,

i have walked, , ,

loup
loo, , , white wolf, roooo

at the,

　　shining riverbank,

　　　, the water's violent flows

　　　　　　　　　　　, all,

 loup
 sewn up,......loo, white wolf, (loup, hair raised, ...)*

(February 2, 2012, a line from the letter from Ms. Tomoko Takemura,...)

"like (,) the edges of a grey wolf's eye, , , ha, ha, ha, ha, , ha, ha, ha. . .

folding

 up

 the yellow springs of hades,......(even the wolf/loup, folds up, his heart,
 politely, the loup of Ishikari,...)

 wolf, loup
 , ishikari......loup
 (loup, hair raised,...)*

 loup
loo, white wolf, from far away, faintly audible, the voice of reality, came to us, , ,

: TRANSLATED BY JEFFREY ANGLES

 Previously appeared online in *Guernica* and in *These Things Here and Now: Poetic Responses to the March 11,*
 2011 Disasters (Josai University Press, 2011).

Translator's Notes

The inaudible "whistle" is a synonym for the "whisper" that appears in a subsequent line. In both cases, it is something like an oracle, a divine message, the intimation (perhaps from the world of the dead) of Gozo's vocation. Since the 2011 earthquake and tsunami, Gozo (perhaps like Polish WWII survivor and Nobel Laureate poet Czeslaw Milosz) has felt a sense of survivor's guilt sharpen into intense literary obligation.

In Japanese, there is a preposition, "wo," between the verb "to hear" and the object "whistle." To wit, we say "I hear *wo* an inaudible whistle." The translator retains this "wo" in the English translation since: (a) Gozo treats this preposition in a special manner, adopting kanji for the otherwise simple, usually-hiragana-written preposition "wo"; (b) the kanji Gozo uses for "wo" suggests the shape of a whistling mouth; and (c) "wo" makes a visual rhyme with "who" (end-rhyming with "Rhu") and a phonetic rhyme with "Gogh." Such visual and phonetic wordplay occurs throughout the poem and the translator initiates corresponding wordplay in English.

By spotlighting the multiple and simultaneous connotations of Japanese script, Gozo's poetry investigates the complexity of Japanese language and extends the limits of the linguistic art. Gozo's language is so extreme that, paradoxically, it forces a translator to think about elemental questions such as what constitutes the Japanese language and how is it different from other tongues.

In Japanese, depending on the kanji, "shi" can mean poetry, death, the subject "I," a history, (one's) will, a man, etc. Here, the translator has tried to emphasize the sound of "shi" in the word "watakushi," which is a formal way of expressing "I." But "shi" is also a bamboo sieve, an image that recurs throughout Gozo's writing and in his films. As a winnowing sieve, "shi" is associated with an indigenous tribe, the Sanga, in Japan and also with Derrida's early interpretation of "khora"—from Plato's Timaeus—as a kind of presupposition of possibility, a precursor of what Derrida later calls *difference*.

"White wolf" is a motif that began to appear in Gozo's poetry after the 2011 Tōhoku earthquake and tsunami. In kanji, "white wolf," 白狼, looks almost identical to a tsunami's "white wave," 白浪. And the kanji for wave, 浪, is "Nami" which we find in the name of the poem and of the town, Namie, whose residents experienced the trauma of the tsunami and subsequent radiation exposure. Also, the words "Loup" and "Ryu," appearing in the same line, suggest "loup-garou," *werewolf*. The werewolf might be thought to be a metaphor for radiation released by the cracked Fukushima

Namie, or the Blue Door

———

and I, too, hear an inaudible whistle, wo · · · · · ·
watakushi /shi/ I, · · · · · · white wolf, *Loup!* · · · *lóng*, dragon, *Ryu!* · · ·
is the mist of the /shi/ sea, *louuu*—, *ryuuu*—

/shi/
"Fukushima Daiich Nuclear Power Plant (tô-tower), *is violet*,......", a voice, a
whisper,,, *who is this* !

is the mist of the sea, *louuu*—, *ryuuu*—

and I too, hear, an inaudible whistle, *wo* · · ·

reads
U<u>kk</u> ッ <u>Ke</u> tt ッ, <u>To</u> tt ッ, (U-ke-to,,,) · · · *is,* · · ·Blue Door, · · ·

leads
Blue Door, · · · *is Wisteria Blue, Violet Apron, ne, Isn't it, 'van Gogh?'* · · · · · ·

<u>Mo</u>, U<u>kk</u> (*mo-u, mô*) · · ·, anymore (*mo-u, mô*),,, whether it's a tidal bore or a
roar,

I
or the imploring color, the violet 、 、 、 , ***a i*** just dunno !

is the mist of the sea, *louuu*—, *ryuuu*—

and I, too, hear an inaudible whistle, *wo* · · ·

15MAR2013......Speaking of this manuscript......, no, I don't like this and I'm rephrasing it,......
I was living in, or lingering on, a different time for a while......, In a sense, I spent another phase of
time, no, "spent" is not the word......, I 'came across' or I 'had entered' a new phase, face, or tense,
of the time in these ten days......I'd promised Sayuri Okamoto-san in London,......to complete my latest
Ciné on Namie in Fukushima, along with this manuscript, to present at a poetry festival which I would
be attending in July in the UK. And the promise, or the fact that I'd made the promise with her, had
grown and metamorphosed into a streak of light that affected the movement of my writing-hand.

Nuclear Power Plant or for the half-worldly, half-otherworldly nature of the "writing hand" of this composition.

With U-ke-to, Gozo is: (a) deconstructing the name of the Uketo River which runs through Namie; (b) giving a strong staccato to each syllable U, Ke, and To, and (c) adopting a kanji for which U is written as 宇, meaning universe, Ke is written as 毛, meaning hair (implying female), and To is written as 戸, meaning door. This sort of paronomasia, also characteristic of yakuza or punk slang, is very unusual. It would be as about as strange to Japanese readers as, for French readers, the poems written by Francois Villon in a lost underworld argot. In the same way, Gozo re-ciphers the kanji for Uketo River to read as "Blue Door."

"Violet Apron" is a motif honoring Takaaki Yoshimoto, a philosopher and poet who died exactly one year after the March 16, 2011, earthquake. Gozo began transcribing Yoshimoto's poems every day as part of his "poetic obligation," as a poet who survived both the earthquake and the death of Yoshimoto. These transcriptions are inserted, like flower offerings, into Gozo's "Monsters," large-scale palimpsestic collage texts that he has been constructing since the 2011 disaster.

· · · · · ·And finally, finally, · · · · · ·this morning,,, the poetry quietly took its complete shape On looking back, the late Yoshimoto-san's poem which I'd transcribed from his 'Hidokei-hen' ('Sundial', a collection of his early poetry) ten days ago—or more precisely, the words "violet" and "apron" in his poem—,,, were grafted onto my poem by my writing-hand; they emerged to my surprise—although I might have expected that to happen somehow Or 'The Letters of van Gogh', which I've been rereading devotedly these days , or the light of his letters, might have prompted my hand too The color "violet" or "whisteria" and an "apron", and the faint image of a woman (who passed away in Namie), or her invisible vestige (yet-to-see), had all been imprinted on the retina of my mind and were standing by [at the *côtés* of] this poetry, · · · · · · .

———

: TRANSLATED BY SAYURI OKAMOTO

Translator's Notes

———

"Mo Chuisle" (both the poem itself and the translation) comes with a history I stumbled into after translating two other poems for this anthology ("Naked Writing" and " 火 · Fire: To Adonis"). I asked Yoshimasu to select a new or unpublished poem to translate. The answer was a warm invitation to dinner on Tsukishima (an island on the Sumida River in Tokyo) over which he told me in enthusiastic detail of the genesis of his poem—one which ended up guiding my translation methods.

In April of 2012, Yoshimasu was invited to Paris for an event with Martinican writer, Patrick Chamoiseau, where Chamoiseau presented his meticulous, insightful reading of Yoshimasu's poetry. Yoshimasu devoted most of the discussion to the effects of the Eastern Japan Earthquake of 2011. He was so moved by this exchange, that upon returning to Tokyo, he set himself to reading Chamoiseau's works in Japanese translation, finding particular inspiration in two of his works: *Biblique des derniers gestes* (which in Japanese translation became カリブ海偽典, roughly meaning *Caribbean Sea Pseudepigraphs*, or *Dictionary of Caribbean Lies*) and Chamoiseau's collaboration with Raphaël Confiant, *Lettres Créoles: tracées antillaises et continentales de la littérature: Haïti, Guadeloupe, Martinique, Guyane, 1635-1975* (in the Japanese, クレオールとは何か ("What Is Creole?"). As this poem testifies, the encounters with Chamoiseau and his writings were profound experiences for Yoshimasu.

In November of 2012, Yoshimasu reciprocated for the Paris event, inviting Chamoiseau to appear with him at the Institut Français in Tokyo. This event featured Yoshimasu's poem dedicated to Chamoiseau's "writing hand," translated simultaneously into French for Chamoiseau by Sekiguchi Ryōko, a Japanese poet and translator residing in France. The event was moderated by Michaël Ferrier, a professor at Chuo University. Yoshimasu read "Mo Chuisle" slowly so that the French version would resonate as a close echo, meaning that Yoshimasu could feel Chamoiseau's visceral, affective responses to his poem the moment it was first read aloud. This corporeal exchange corresponds to the importance of the text's own materiality.

Yoshimasu completed this framing tale, and I left the evening toting a bag full of Yoshimasu's personal copies of Chamoiseau's writings in Japanese translation, with a disheveled rainbow of sticky notes protruding from every margin. And copies of Yoshimasu's handwritten poem, "我が鼓動 / Mo Chuisle."

My Pulse

Mo Chuisle——dedicated to the writing hand of Patrick Chamoiseau

———

NOV 17, 2012, all you kind souls gathered here at the *Institut Français* this rainy evening This humble poem, deeply inspired by Chamoiseau's masterpiece *Biblique des derniers gestes* (translated into Japanese as カリブ 海偽典 / *Caribbean Sea Pseudepigraphs*), was written in full awareness of my shortcomings and with all my heart. His masterpiece yields enormous blessings. I kept on reading a third, a fourth, a fifth time. Herein, I share my immediate surprise and gratitude. This morning, I sent a facsimile to my friend, Sekiguchi Ryōko, who will be giving the gist in French—along with my joy in getting to spend the evening with this marvelous writer.

NOV 12, 2012, 3:00 P.M., *Tokio*, . . . *Patrick Chamoiseau*, his masterpiece, translated into some one-thousand pages of Japanese by Tsukamoto Masanori, after reading for ten days, I finished it, such words, their very existence seems impossible, but . . .

I felt like a most courteous, giant tree was 樹-間[=stand]ing in my kokoro, ,,,

6:00 P.M., NOV12, 2012, Perhaps this "kokoro . . ." thing, surprised at its initial surprise, page 906, third from last line, "Orchids are intimate with eternity, frugal, slender" while I regret losing my friend, Nakagami, I feel his narrowed next to me, giving me the feeling *I can see Chamoiseau*-san's French in the first line of this poem, What does it mean "to mourn" (おしむ)? (it can also mean slowly savoring one's reading to avoid the disappointment of finishing, but it's something deeper . . .) And, perhaps, this mourning, felt for the first time, when I finished reading the book, 樹-間ing in the heart of the book, was this circling round and round, Or Balthazar Bodule-Jules, whose body "watered, pulled weeds, cleaned up" (page 886, line 7), his movements, the sound of pen scritching on the paper of Patrick Chamoiseau-san's "paper house," or coming to hear the soft "soundless whistling," I find myself softly, cautiously returning to the depths of the book's first page,

The abyss of our voices, ,,, it may have been the first time I'd known a future where my whistling could arrive, ,,,

A reading of the poem begins and ends with the title phrase, though it crowns the poem with a macaronic twist. We learn its basic meaning at the beginning, but we come to experience its full sonic resonance only at the end. The Gaelic phrase (pronounced "mō ḥush'luh," beginning with a lightly throaty Germanic *ch*, like a softer Hebrew ח or the Arabic خ) literally means "my pulse," and functions generally as a term of endearment. Yoshimasu's title is glossed with the Japanese phrase "*wa-ga kodō*" (我が鼓動), literally meaning "my pulse," but without the normal register of the term of endearment.

This literality of translation is embedded in my non-translation of the word *kokoro* (心). In the lines about the tree standing, the speaker's "kokoro" would normally be translated "heart." But as noted in 1957 by Edwin McClellan, the translator of Natsume Soseki's modern classic novel, *Kokoro*, the word does not quite correspond to the English "heart." McClellan kept the Japanese word as the title for the English version, explaining that it can suggest something like the *emotional center* as it does in English, though it does not designate the anatomical heart—indeed, in Japanese, the anatomical word for *heart* incorporates the character kokoro, but is semantically and phonically distinct (*shinzō* 心臓).

This character "kokoro" (心) is also present within the Japanese word for "center" (*chūshin* 中心), used elsewhere in "Mo Chuisle." I have therefore translated phrases like "center of the book" ("書物の中心") as "heart of the book" to extend the resonance of *kokoro*. Since, despite McClellan's creative intervention through Soseki, *kokoro* is often translated as "heart" or the equivalent in Western languages, the change from the more literal "center" of 中心 to "heart" might also be thought as the insistence of the metaphor in Japanese *ecriture*.

Several others of Yoshimasu's innovative constructions must remain in Japanese, rewarding readers for their diligence. Japanese readers would encounter them with only slightly less initial confusion; this is therefore one of those instances when translation pulls an interpretive riddle into the spotlight. The most prominent is "樹-間," which functions in several ways through the poem: as *tree*, *to stand*, or (tree) *bark*. It parallels the Japanese word for *human*, 人間 (*ningen*), one rich in philosophical implications. The word 樹-間 itself is Yoshimasu's own invention and combines a slightly literary character for *tree* (樹) with that for *space* or *between* (間), separated (or connected?) by a hyphen. Philosopher Watsuji Tetsuro's analysis of the Japanese concept of human—embodied in the word 人間—shows an entity based essentially on a relational *betweenness* (*aidagara* 間柄), a being constituted through a set of relations to others in constantly varying situations and environments. Sensing this resonance with Watsuji's theory, I left the word in the original with bracketed explanations adjacent as meanings change.

"It's not enough"
"*Apatoudi*" = no, that was enough, „,

NOV 13, 2012,......wordless symbol of a poetry anthology dedicated to *Patrick Chamoiseau-san's* masterpiece or the "„," resembling someone's mouth, for example page 896 to page 897, "......the atmosphere saturates with moisture, becomes mist settling on walls, on life, and the orchids drink it in" の,......that scar on the universe I made, "„," 毛, thank you, *Chamoiseau-san*,......

„, 環, I was approaching a path along which I would realize the meteoric nature of that mist the orchids sip

11/13/2013 (Tues) 13:27 ORGANIC CAFE, Tokyo Station branch, off in one corner I sat, as though sheltering myself from the rain though it had ceased to fall, from the power of that falling mist of Chamoiseau-san's book. Page 39, the *3, hearing for the first time the "tiny cracks in the hummingbird eggs," the path and my life aligned, there was a "sing=walking," I sang-walked / chantai-marchai. Touching the book's bark, the 樹-間skin, touching = left,ring,distance,what,add,nudity......(sa左, wa 環, ri離, na奈, ga加, ra裸,...... page 47, left side, "There is no beginning of death. It exists from the moment of conception, envelops our births, dwells within all alive, remains an active principle in all our projected futures. Death composes the reverse of extreme life...It forms the reverse."

little paths on the reverse of mist meteorites 緒 while drying out words, I made as though to whistle "Hey, Moon! Over here...," on the REVERSE of the "text route," those paths on the REVERSE 緒, we came to walk for the first time,...

NOV 14, 2012...immersed in perusing, *Caribbean Sea*, for the second time, I found, perhaps, my favorite line in this *monumental work*,...page 85 8th-6th lines from the bottom, "Cléoste, between the huge roots of the trees, in the midst of this darkness with mist dripping like rain, moved along as easily as though brightly illuminated by the noontime sun," 加 but

water, **w**ater, „, the **m**ist's emphasis, **w**ater, **w**ater, moving along easily, Tsuna**mi**乃victims, so easily, those 樹-間[**t**rees] ar,ranged, "***baji*RU** = basil, THAT RU = RUE = ROUTE", sounds of muddy footfalls, beca**m**e visible

Chamoiseau's most courteous, giant tree—I felt—was 樹-間ing in my kokoro, „,

"Bajibaji (basil: [in Creole folktales, another name for death] page 90 (*What Is Creole? [Lettres Créoles]* Heibonsha Library Publishers, trans. Nishitani Osamu)

ruruRU......" ru = the Ainu word for little path, road)

The uses in the poem are:

Original	Pronunciation	English Meaning	Translation
樹-間	ta	stand(ing)	樹-間 [=stand]ing
樹-間肌	kihada	treeskin	樹-間 skin
樹-間	ki	tree(s)	樹-間 [trees]
樹-皮	kawa	(tree) bark	樹-皮 [bark]

The first usage boldly grafts the semantic meaning of *standing* onto 樹-間. The second, combines 樹-間 with 肌, a word usually used for animal (including human) skin. The third implies that trees also gain their existence, essence, or "treeness" through relations with other trees, animals, humans, and the environment. The fourth relates to the second, but 肌 is replaced with 皮 (*kawa*), suggesting a leathery hide.

"Mo Chuisle" also employs the homophonographic play of *ateji*. I have followed the same technique as in translating "火・Fire," setting the semantically designated phrase first, then adding a literal translation and romanization of the phonemes at play. The first ateji phase in the original is literally "while touching" (*sawari-nagara*), written using 左 (*sa*/left), 環 (*wa*/ring), 離 (*ri*/distance), 奈 (*na*/what), 加fi (*ga*/add), 裸 (*ra*/nudity). In this vein, Yoshimasu also uses the character 毛 (hair / *mō*) to stand for the homophonous Japanese particle も (*mo*). Fortunately the context allowed me to translate using the word "more," which I've glossed as "(mō)re" to allude to this instance of ateji. The article を (pronounced as a long o) indicates the preceding phrase as the object of the verb; Yoshimasu grafts over it the character 緒 (*oh*), meaning thread, clue, or beginning. He switches 加fi (*ga*) for "but," thereby implying "addition" of something else.

Gya-ri-ri = [in Creole means "over there," "that world"] (What Is Creole? [Lettres Créoles]
Heibonsha Library Publishers)

NOV 15, 2012...IN A DREAM, the DREAM's 樹-皮[bark], stripping sounds,
the swelling of Chamoiseau-san's pen, to its absentmindedness my kokoro was
returning, thinking,......(Mō)re than Edouard Glissant's "A tree is a country
unto itself" (What Is Creole? [Lettres Créoles], Heibonsha Library Publishers, page
307),......

An absentmindedness like the absentmindedness of old trees . . . (Biblique, page 104,
eighth line from the bottom), gya-ri-ri,......
Gya-ri-ri
"the planet's bark, ,,," "the green clay of the Congo swamplands,......
(page 45, last line)," Gya-ri-ri, pi-pi-ri (Pipiri bird, page 137, seventh from last line)
Ri-ri-gya, jiba...— reversing the syllables made a splitting sound

NOV 15, 2012,...so finally, according to the "the 樹-間's absentmindedness," in Chamoiseau-san's
praiseworthy masterpiece,

The dying, ,,, "a dwarf, an emerald,......," the dying, their singing voices, we
also noticed......

Ri-ri-gya, jiba — reversing the syllables made a sp.lit.ting sound
Ri-ri-gya, jiba — reversing the syllables made a sp.lit.ting sound

NOV 16, 2012,...perusing a bit (mō)re "departed spirits from a past age, marginal, latter-day avatars of
escaped slaves" (page 134, first line), and "it seemed as though the door to the room had disappeared"
(page 113, third line) 手, invisibly "guided by an animal sense of smell..." (ibid, line 12), 手, grow.wing
deep.her...

(= "discomfort" (page 116, fourth line))
the entire universe "an absentmindedness like the absentmindedness of old
trees" = "Some things are, some things are not. And between the two lie the
remainders." (page 111, epigram,...)

the immortal, invisible depths of the remainders, ,,,

Ri-ri-gya-jiba, ri-ri-gya-jiba
Incredible, the ashen tamarinds (page 137, last line) of
the 樹-間 [tree]'s URA-KAZE, its DEEP-WINDS

NOV 16, 2012,…9:00 A.M., I got a phone call from Ryōko Sekiguchi-san, in Kyoto with
Chamoiseau-san…. "last night we drank *kokutō shō chū*,"……

Incredible, the ashen tamarinds of the樹-間[tree]'s URA-KAZE

NOV 17, 2012, finally, on the morning of the day that URA-KAZE's six, seven days' journey would come
to an end, listening carefully, I began to hear the voice of another poem,……

ta so many
tama,…… souls, ……

"The remainders,……" the moment I spelled it out, the voice of Rikuzen
Takata spoke
Yes
Incredibly
Cha<u>mo</u>iseau,
<u>Mo</u> chuisle ("*my pulse*," Gaelic)

I felt like a most courteous, giant tree was 樹-間[=stand]ing in my kokoro, ,,,

afterword,……As I finished my reading, listening still to the faint voice
of the French simultaneous translation, I mumbled, "This poem cannot
be written again, can never be read again." (the author).

———

: TRANSLATED BY JORDAN A. YAMAJI SMITH
Published with the article, "Of Words and Worlds: Toward a Critical Reportage —— Translation with
Yoshimasu Gozo and Patrick Chamoiseau," in *Annales de littérature comparée* (Hikaku Bungaku Nenshi).

Translator's Notes

———

This translation of Yoshimasu Gozo's "Naked Writing" ("裸のメモ") is more of a groundbreaking ceremony than a translation: it calls for more work by teams of variously trained professional and amateur readers to complete the monumental task of construction—an architecture of collective interpretation. I will not pretend to speak for the poem, or on behalf of Yoshimasu, though we have had many interesting exchanges about this translation. A few comments are essential to discern the translator's hand as it traces and effaces the author's. Many of these comments may seem like minutiae, translatorly hyperattention; however each leads to insight about the poem itself, about Yoshimasu's innovative and complex style, and about translation itself as a process. I would go so far as to say that Yoshimasu's poems could be called *translatorly* texts: conversations emerge around the choices of translation, which is precisely what the poem seeks to initiate.

On the first page, Nui-san is the name of a person "Nui" with the Japanese honorific "san"; it is a pun on the kanji, which is 縫 (nui), meaning "sewing." The "eyes" could be those of Nui-san/the seamstress/tailor, his/her assistant, or the crimson boat. This translation ties them to the suggestion of a vague but definitely human figure; preserving the ambiguity would be ideal.

Yoshimasu's writing is rich in puns and other innovative wordplay. The following line from the second page reveals the length to which the translator must go in order to preserve it: "......thought, whiz, purr......a voice, hair (air), could be herd." Here—and throughout "Naked Writing" and elsewhere—Yoshimasu utilizes a type of wordplay known as "*ateji*," a replacing of the typical characters with homophonous but graphically distinct characters, a kind of visually dissonant *homophonographic play*. Here, he replaces the Japanese verb for "to whisper" (*sasayaku*) with the following characters, separated by *kutōten* (Japanese commas): "左、左、矢、苦" (literally, *left, left, arrow, suffering*). I chose to maintain the integrity of the phonically signified "whisper" rather than maintain the rather visceral graphic suggestions. If a translator of Yoshimasu were to bemoan the losses of translation, surely that could happen in regard to this primary decision: whether to privilege the graphic or the phonic in instances of ateji. To suture the gap created by this compulsory choice, I have taken the liberty to downplay semantic-centered translation and attempted to create new forms of word play arising naturally

Naked Writing
(Like P. Klee, one must slowly carry fire from the heart to the hand…)

———

a dressmaker (……'s Nui-san, seamstress,……), her goddess's, *yamamba*,,—
—*tatami* mats and straw matting be(came) sheets, the sheets a crimson
boat,……(her eyes,……), dyed amber, an awning boat (篷船 péng chúan)

ash gray (잿빛 · 회색 : [tʃɛtp'it : チェッピッ]), thornily, starfish (astèria. FEMININE NOUN)／,,

Pit! Chep'pit!

(Summer of 2009, on a certain day in a certain month, at Shinjō／, station's rental car／, a Toyota
Vitz (metallic silver), spun round, by its GPS navigator, of Mamurogawa (真室川), of Ōishida (大石
田),, so fast, place names (blood names,……) they, disappear!,……so it's said, the old folks, were
mum/bling,……spun round, wandering lost, time was real time,……to the Mogami River where
no one is, is the Mogami River where no one is,……repeating wordlessly in the days when I tried to
sing, twisted like the wick of a wordless song, the curving 口 (mouth) of the Mogami River, the river's
words,……Not lonely, not quiet. The hidden homestead for a corpse in its currents,……I thought,
whisp,her (左left 左left 矢arrow 苦suffering)……a voice, hair (air), could be herd, coming but, rather "over
their" saying nothing, it was the mouth of deep words,…… "A mouth that says nothing,……" and a
Vitz (metallic silver), I met with all this, in summer of 2009, on a certain day in a certain month……↻
But for fifty years, sixty years, it has been traipsing after my heart,……Perhaps the Sagae was ↻
shaped,,,

Perhaps the Sagae was ⌣ shaped,,,

Pit! Chep'pit!

Instinct, incomparably beauteous sigh
 lent, not silence,
 the waves of Tokoyo, the Eternal Land, sometimes,
 (I can't hear……) clear my throat,
 (*balbettio*, hemming and hawing man. MASCULINE NOUN),……his gig(antic,)
 sospiro sigh. MASCULINE NOUN ……therefore,,, he is

from the sounds of English; hence the semantically unrelated phrase "whiz purr" for whisper, and the homophonic resonances of hair/air and "herd" in place of "heard."

More complex instances of ateji occur, where a phrase may be read as a string of random words and sounds; strictly speaking, the sounds do not form a grammatical or identifiable phrase in standard Japanese. However, in one passage, Yoshimasu repeats the initial sounds of the past progressive "was remembering" (*oboeteita*). The initial *o-* sound appears twice in different forms: "[ト …] ヲ、尾、覚えテ、いた" ([*to* …] *o, o, oboeteita*). The first "o" is an object particle; the second means "tail." So if we read semantically, we would have "was remembering the [door] object marker, tail." But the framing sentence contains so many repeated sounds, it would be hard to ignore the impression that the speaker is stuttering over certain words:

無限ノ、乃ノ、カタツムリノ、乃ノ、ト(戸、扉、……문 · 출입문
[mun: ムン] ヲ、尾、覚えテ、いたことハ、たしか、駄ッ多

mugen-no, nono, katatsumuri-no, nono, to (to, tobira, ……mun/chul ib mun [mun: mun] o, o, oboete, itakoto wa, tashika, datta

This stutter which yields to meaning emerges again in the sentence: *to*/と becoming *to*/戸, becoming *tobira*/扉, and then door, which becomes another *door*.

At the end of this sentence comes a phrase not to be confused with ateji, when Yoshimasu borrows from the older writing tradition in grafting kanji (Chinese derived) characters over the casual form for "was," *datta*. He replaces the *da* with 駄, and *ta* with 多 to make "駄ッ多." 駄 means "nag" or "workhorse" and is used in various compounds to indicate something vulgar or worthless, while 多 means "many." The connotation of "manifold uselessness" is subverted by the stutter, yielding new meaning through its playful discovery of homophonic affinities. However, the phrase 駄ッ多 can also stand out as a more common writing convention dating, perhaps, from as far back as the Edo Period. Overall, the phrase works through the layers of interrelation between Chinese, Korean, and Japanese writing systems.

The next page also includes my construction "mum/bling," an approximation of the linguistic play in the original, where the colloquial past progressive "was mumbling" (*tsubuyaite'ta*) is represented by ateji. In this case, *tsubuyaite'ta* is broken down phonetically (literal English equivalents are in parentheses): 粒=*tsubu* (small piece); 焼=*ya* (roast/grill); 居=*i* (to be/is); 手=*te* (hand); 多=*ta* (many). In Japanese, the second-order semantics arise from phonic uniqueness of Japanese, and hence in the translation, I let second-order semantics play second fiddle to the sound of the English word "mumbling" with its own phonic resonances. I wrestled with the passage translated as "sigh / lent," with

(Until I named it "Naked Writing," the narrow path of this "Essay / Narrative," *came* walking Yes, the narrow path, the autumn air, the first rain to herald winter, Ah, so-la (sky) *it is* ! la, 塊 (clump) of attention Yes, this, yes, this, things's, dependencies, damn 'em, an atom of anatomy of you dependents, *mino* (straw raincoat) or *kasa* (umbrella) or voice or words the seamstress's things her variouses, all together "Rah! Rah!", it was the narrow path (lane) we were walking it was, the 果 (end) in 裸 (naked), its geta, there was a time when it became Paul Klee's ☞, our ☞ somehow, prehistoric 牛糞 (cow dung), underneath it, it looks like a vacant lot (空地),, p, lay, ce, from which you might bashfully cast your eyes downward,, we made it to that *place*, man. *Geta*,, hawk, serving time, Buddha, barely started to walk, To the next town, one could say, *hmph*, All the way to the next town over, Muscatine, Iowa on the *Mississippi*, walk(by car)ing forty years, not yet, ssissippi, the first late autumn rains of it's i, it can be, it can't be, escaped, P.'s, annotative head jots, also (all so), escape (SCAPE), no way, no way. For forty years, just like this, just walkin', man. From Ōizumi Fumiyo, the morning of February 2, 2009, Monday, A new edition of "A Quiet Place," a fax arrived, Afterword, due by the twenty-fifth, the most surprising part may have been their calling it "A Quiet America," *si* or *shi*, Shimokitazawa, 死人 (*si, bi, to* : the dead)'s, because it's the land of the *urushi* swamp, Mr. Saku's "Suicide by Hanging from the Ceiling" [*tenjō ishi*] of Shimokitazawa's, i, *shi*, to notice this was Nakagami's or Ryuta's god-given nature, but, I, today, am surprised at the me that could be surprised at something like this,. "A Quiet Place" original edition page 60 line 3, What is this ☞ surprised at a place like that! "...... This place called Watts with its mysterious tower. Italian-born Simon Rodia (1879-1965) for thirty-three years, using shells, cans, metal scraps and such, erected a tower with his bare hands," Eh!!!

Eh!!! Coca Cola, Pepsi, tower of shells!

In this way, oh 髭 (goatee,) of Nguyễn Cao Kỳ,, Machu Picchu,,

("Suspending a Harmonium in this Circle" and, "A Quiet Place" bore an epigram thirty-one years ago, thirty-one years have passed, with that mistymouthed, "shell" or "Charms from Mt. Osore" or "Apparent Selfasphyxiation," too, life, The warm thread of life's "when we touched one of its ends, the other end swayed." (Chekhov/Awadzu Norio, — "On St. Peter's Denial," *Anthology II*) on page 138, he writes, "Rembrandt inspired Bach. If you touch one end of a chain, the other end sways." Yes,, yes, 정말 [*kure*: クレ] Klee might not understand, however (ever), that's right, he might understand, however, this,, "mooring rope *kanashimo*," that's right. When I'm washed away to Sado Island, the voice of "Naked Writing," Zeami's writing, "Ah, so intriguing, the sea at Sado,," ノ, yes, that voice, February 18, 2010, toward the Driver's License Renewal Center in Kandabashi, listening to the mum bling (mumbling) of Kanda's muddy boat's prow's captain of boat of filth impurity and

the enjambment separating what a reader might recognize as "silent." In the original, the word *chinmoku* (沈黙), meaning *silence*, is separated into 沈 (sinking) and 黙 (quiet). Read separately, the second line emphasizes the *lack of silence*, while our reading across the enjambment causes the hallucination of its presence, or at least the presence of the sinking component of <u>chin</u>moku, minus the silence of chin<u>moku</u>.

One translational impossibility was to convey the neologistic pun of 地名 (*chimei*, meaning *place name*) and 血名 (*chimei*, Yoshimasu's invented word suggesting *blood name*). Both "blood" and "earth/place" can be pronounced as "*chi*." In the original, place is tied to blood and then tied to name: the geographic is corporeal/sanguine, and both meanings suggest a crucial lineage.

At several other points, Yoshimasu incorporates mid-sentence the pairing of two characters "モ" and "毛," in a unusual play on their visual parity. モ (the katakana character pronounced "*mo*") is essentially a suggestive sound in this context; by itself, "*mo*" can mean "also," though it would usually be written in hiragana; in the second occurrence, I have therefore translated the pairing "also (all so)." The second character in the pairing, 毛 (the kanji character pronounced "*ke*"), means "fur," "hair," or occasionally "feathers." In the first occurrence, the reader experiences confusion as the character for fur/hair suddenly appears in the middle of the sentence; my translation here of "hair (air)" echoes the visual parallel of the Japanese and the reader's experience of the writerly graphic wordplay, that is, when the semantic meaning evaporates, leaving us to grin as we puzzle through the rest of the sentence. The モ/毛 play repeats on the next page, where the sound "*mo*" comes as the final morpheme in a transitional "however" (*-keredomo* / -けれどモ), and is again paired with the visually parallel 毛. Here, I translate the pairing "however (ever)." In each instance, I have chosen to privilege visual correspondence in English, but in both cases, at the sacrifice of the more tactile, haptic sensuality of the original Japanese.

By giving equal status to references from classical poetry, modern poetry, and television documentary, Yoshimasu also exalts the everyday, highlighting its connections with richly meaningful topographies and cultural histories. This natural synthesis, parallel to his playful translingualism, should be seen as a hallmark of Yoshimasu's poetry.

danger,......, they say, the mooring rope, THAT chain, drags and clanks, so, so, と,......those goddamn genes too, a bully's, like a 鬼瓦 (gargoyle), that he got rowdy, that was CERTAIN,......this area, something like leaves of old newspaper, piling up in a vast rotting heap, my heart's 泥 (dirt),,......YOU, thief [泥棒], YOU, thief, YOU, thief,,,,

rope (밧줄 .줄 [pat'ʒul : パッチュル]), hand (손 [son : ソン]),, reaching, and, 唖ᵃ, 離ʳⁱ, 唖ᵃ (aria, FEMININE NOUN)を,,.

triste, sadness, in a dream, a tree splint, where to,
 Masamune, oh, Hakuchō!
 That
 fragrance,
water (물 [mul : ムル]) embroidery ノ、乃、
ノ、fragrance ((香気)가나다 hyangiga nada = かおる: to give scent) , kapchagi (갑자기 .느닷없시)

a dressmaker (......, 's Nui-san, seamstress,......), her goddess's, yamamba,,
Yoshida Kazuko-san of TONDABAYASHI, I wonder if she sketches wavy lines
on that TON, of bamboo joints, like an HB pencil,......

(So, Iwata Shinji-san, d,id an "NHK Special,"Tondabayashi's own Yoshida Kazuko-san,
84-year-old, began to learn,......

Jii (波線 (wavy lines), knowing almost nothing of them, oh, Kafka, Tondabayashi's own Yoshida
Kazuko-san now, ring finger (pinky?), s'port,ing,......used it as a supporting crutch,......This
scenery, I (like a poisonous insect,......) my, ノ, : —umlaut. That's right, Germanic boat, the galley's
sound's, ink pot,......, chamber pot,......)

shit (cacca. ITAL. FEMININE NOUN), —, ring finger (pinky?)を,, where to,,,
Fried - rich
Nietzs, che
he,,
Venezi, i, a
, a, no's

(Gone, do, la, 's) song,, nii, ne, jii,,.
So, so as though it (attach— 붙이다.덧붙이다 [putʃ'ida : puchida])'ed
Ring finger (pinky?) を,, where to

Tondabayashi's own Yoshida Kazuko-<u>san</u>,, well,, shii, <u>jii</u>,,,
put,, chida,, (attach——붙이다.덧붙이다 [puts'ida : puchida) eh,,, ツ,,

(February 13, 2010, morning, 6:40, IN Kasumi, WITH Sato Masayoshi-san, last Year of the Rat (2009, December) 31st, at three o'clock, just at year end, I was trying to get out to meet him, just when, just then,......, sudden new,s came, he died,,, ノ, wind blowing,, wind blowing in the form of an unseen hat. That "that gesture and that smile at picking up the unseen hat,...... " was a memory for this lifetime,——. A bamboo rake, if only I could've bought a new one, at the Kasumi Branch Office in Hachiōji,......He must have fought around HERE,......surely, here (HERE) was the battlefield, Takeda's and Hōjō's, which one of those struggling young people, one of their profiles suddenly thrown into relief,......And, without noticing it, we, at the fragrant snowbell (白雲木) in the garden, we lingered as though we'd talk to it, is that, a cloud? A spider? At that, you could say we began to notice......In that beautified garden, that,......, or that,!!! Incomparably beauteous coat of fur, like an HB pencil, alone, see, a quiet raccoon=狸,,,, as I quietly flipped the pages of the Korean dictionary,, noguri (raccoon tanuki [狸]) ⊖ 너구리 [noguri:ノグリ]). Isn't it this cloud, this wind, Masayoshi-san, Kazuko-san, Shimokawa-san, the winds', 's, the noise the cLOUDs make,......noguri, no, guri......let's go walking. Knowing no limits,......that was IT,......noguri, noguri, to those, THOSE quietly upturned eyes, I, limitless's, s's, SNAIL's, 's's, do (or door, 戸, 扉,...... 문 · 출입문 [mun: ムン] ヲ, tail, I was remembering it, surely......

I will arise and go now (W.B. Yeats)
Noguri, noguri, "Refreshed now, arise and let us go walking"

> Instinct, incomparably beauteous sigh
> lent, not silence,
> the waves of Tokoyo, the Perpetual Country,
> sometimes,
> (I can't hear......) clear my throat
> (*balbettio*, hemming and hawing man. MASCULINE NOUN)

(And also, beyond this, never again,......so they say butT,, from here on out, never have to go out walking again, like I'm some young Yosa Buson on his journey north,...... I declare, Shōin was like that too, and Arthur Rimbaud,......, from then on, relaxing now, briskly,......as though embodying a "Me, I don't have a CLUE, MAN......" just like that, get the hell away, end it,, rela,xing now,, in those days, never once in my life, I never whistled, man, wish I could hear one let peal like the wind, even if I couldn't hear it, somehow come to hear it, yeah, yeah,, yeah yeah, の,, yeah, yeah,......

Sa,, ╱ , 乃,, sa, sa,, ——
Sa,, ╱ , 乃,, sa, sa,, ——
noguri, noguri, refreshed now, arise and let us go walking
noguri, noguri

———

: TRANSLATED BY JORDAN A. YAMAJI SMITH

II.

Translator's Notes

———

Gozo wrote "Stones Single, or in Handfuls" as an urgent reaction to the 3-11 Fukushima disaster and appended it as an epilogue to his *Naked Writings*.

"Stones Single, or in Handfuls" begins with a partial, distorted quotation from the Japanese children's song, "Tōryanse." Near his flat in Tokyo, Gozo stood on a bridge leading to Sumiyoshi Shrine. As he peered down from the bridge, into the whorls of the Sumida River's flow, he recalled and reimagined the song's lyrics. The quotation brings into question the relationship between memory and making, underscored by this famously mysterious line from the song: "there may be no return once you proceed down the path." Accordingly, some may read something ominous in the reference, while others may even anticipate the immediately subsequent lines in "Stones Single," suggesting comparisons between the endpoint of the "narrow road" and the writing of poetry.

The "poetry making" that Gozo mentions throughout this piece is, for him, like a lucid dream. Gozo attempts to travel through layers of his conscious and subconscious mind to transform, or translate, what he sees, hears, feels, or otherwise senses into the content of his poetry.

Gozo adopts an unusual kanji character for a word as simple as an indefinite article. In the case of "ha," for example, which is comparable to "a/an" in English and translated here as "this" in "this narrow road," he employs 環, "ring," or "circle," despite the fact that the article is written in hiragana, that is to say phonetically, in normal Japanese texts. By doing so, he metamorphoses a simple article, which has no meaning when written in hiragana, into a metaphor for, a reminder of, another of his poems that begins "In this circle, suspend a harmonium" (*Quiet America*). Gozo borrows the idea behind this technique from the Man'yogana writing system, wherein sound takes precedent over sense, so that he may extend the meaning of a word, letting it indicate several motifs, topics, and ideas at once, and in the same ramified way that the word works on his perceptions.

Peach: 桃, an important fruit in Japanese mythology, with added significance when connected with the act of throwing. The *Kojiki* records the tale of Izanagi and Izanami, the god and goddess pair responsible for the creation not just of the many islands of Japan, but all the other deities of the ancient Japanese pantheon as well. While giving

＼ ＼ ＼ ＼ Stones Single, or in Handfuls

———

Sung as a preface,
> "Here, this narrow road, where, does it lead?
> *Tenjin -sama*, over spheres, this narrow road, traverses spheres."

Poetry is (Soaked is drowning is a stitch,,,,,,) a way to a ^pitch-black Perpetual World

Peaches, peaches, golden peaches white peaches
Blind turtle blind turtle — ⌒ the universe
repeats upon your back,,,

＼ ＼ ＼ ＼ stones single, or in handfuls
throwing them
to the sea
I foresee,,,
no "good or bad" fortune
but whether or not there is a song.

JUN 17 2011 A morning that starts the rainy season, ······a sewing box , a needle, a hand, and a *haishu*: the-other-hand, "you've come here this far at last, ······', from behind about /m-ai/ ears, in an uncertain voice,······ *I see, this, is the song of a singer singing in a storehouse…of memories,* ······ I felt spindrift rising from my *se*: back, on a bridge, behind Sumiyoshi-san, ······ somewhere about the A.M. or precisely at 5.40, /ai/ (a subject nearly unnecessary, ······) halted, ·······. *No, emerged,* ······as I was ☞-ing a rush of water, ······a rush of water, that had been brought into Tsukuda, ·······, it was a rushing in the water's eye. a rip (pling) 'on the water's surface' ······· *té*: hand, its *dessin*, ·······. In this way I became a man in a time for water-gazing ······And, *May this life be rid of it,,,* ······though I'd wished and forgotten I'd forgot, I also came to fight against the rising of the tide (and the tide's power ······),,, JUN 18 2011 In NH002-31, *Be a splash broken at the rock's edge or the latent sting of a splash, end the insect twitching of these memos, and break on the last song for the last book*······, I whispered but the whisper was perhaps a sham (*sham*), and perhaps it was the very buzz (*buzz*), the din—*the din!* ······to which the hollow of my ear must be so close ······ where a double pipe (Pushkin's, Imai-san's) sounds, and yes, that was the Mute: "/m-mjú,to ˈ/" ······(oh, Nietzsche): "/mi ˈ/" of *Prunus Mume*. And the /mu/ ; of ^being without m ^dot u ; ^dot ^dot of ten ten ten; of the White (Mume),

birth to the fire god, Kagutsuchi, Izanami suffers fatal burns. Izanagi visits her in the underworld, Yomi, to try to arrange her release from the ranks of the dead. Her flesh has begun to rot away and, ashamed at her appearance, she warns Izanagi not to look at her when he arrives. He doesn't heed the warning; his gaze sends her into a rage. He runs and she sends a pack of undead hell-hags to pursue him. As he runs from them, he approaches a peach tree. He plucks and hurls its fruit at his pursuers who retreat. Grateful, Izanagi blesses the peaches, bestowing upon them the power to ward away torment from mortal men thereafter. To this day peaches remain symbols of good luck and life in Japan.

It is for this reason that Gozo writes in the final lines of his "Lecture on Shinobu Orikuchi," this dedication to 3-11 victims: "for the people who died without dying, I throw huge, white peaches, thousands, over the crests of the waves." The inclusion of peaches in this excerpt from his *Naked Writings* allows for meaningful slippages, especially in translation. One is the blurred boundary between peaches and another type of stonefruit common in Japan, 梅, "ume," or as it is here indicated by its Latin binomen, "prunus mume." *Ume* fruit is colloquially called, interchangeably, plum or apricot, and *ume* can also refer to the tree's blossoms—e.g. the "white plum blossoms" when Gozo quotes Yosa Buson (see below). But *ume*, technically, is neither one. Nonetheless, its potential to be a thing apart, while also being two or more related but distinct things, suggests a pliant and general category rather than precise taxonomy. When peaches and *prunus mume* appear, disappear, and reappear, juggled through this *Writing*, they do so propelled by a whipsaw counter-motion as the pliancy of this general category opens and then recoils with each new displacement. Finally, the referents for *prunus mume* are unsettled enough to call to our minds the *stones* that Ralph Waldo Emerson, in his journal, recollects throwing. Stones, pits, blossoms.

Té: the first syllable of *Te-n-jin-sa-ma* and the one of the many recurring sounds in this *Writing*.

　　1. 手 (té or te): hand, manner, a subject of the action.

　　2. て (-te): while doing something, after doing something.

背手 (*hai-shu* or *se-de*) is an indispensable word throughout this *Writing* and is given phonetic transcriptions (*rubi, kana* readings) of either *hai-shu* or *se-de*, depending on the context.

背 (se/hai): behind, back, to go against; 手 (te/de/shu): hand, way, manner, a parson/ subject of an action. The term 背手 (*hai-shu* or *se-de*) could be understood in two key ways:

and of the aroma of /mjuːt/ White-Mume, ······ were the very Mo, Cui, sh, le, Asu, ra, *ra, na na no da* (yes)

······ JUN 19 2011 A night in New Bedford, ······ "*Up comes the dawn, as the white plum blossoms*" (Buson-san, sang on his death bed to the morning (a Mume in bloom, ······) a mind fragrant ······), I too have come, having reached the final stage of life-long poetry ······ while I was still trembling where my body met my mind and the movement grew familiar, ······ I must color my shivering f u s e ^{Mo Chúisle} with a melody, ······ , And I have come too, to see tattoos inscribed on a lifetime; and sixty years having passed, a distant scream—M! of fossil shells (or rather " ウニ ^{/ uni /} " in katakana, ······) opened full into my palm, in Akikawa, in my youth, began to reach my ears, from a thin crack within my my body (*ka ra da*, or my woMb ······ a receptacle for unsorted memories, ······), ······. It was at the time of the tide, of the fragrant tide,,, a ubiquitous wind ·······. (Neitzsche's, ······) intuitive notion of "Eternal Return", it was like that…a little; the texture and the lines of a passing time, of a fossil rock bore thereby ······a queer likeness to an empty ☛ in the whited skeleton of a man…of men in caves or farther underground and under stone…of a Ficus (Microcarpa) tree ······: The night I swallowed Hawthorne's *Scarlet Letter* whole and circled Poe's 'Island of the Fay', ······ but I knew at the core ^{/ mi /} of my mind that I was trying to breathe to move along and on the winds of their imagination, led by a resurrection in me,,, ^{/ mi /} of something only understood in terms of (the) power (*powar*) of a moment (*memento*) when a single swipe (from a fossil hammer, ······), leaves the body of ウニ ^{/ uni /} naked and bruised, ······ ; but at last, the wind of a *té*: hand of the tender tide (ebbing ······), which blew through singularities,,, it was sixty years having passed clearly being heard, ······, *Thus spake I*, and I'd say I've put it all into words in /m-ai/ own way, ······. Or it might have been the vo, no, i, ce, se, a wind turning in the universe, ······, bounded by an ebbing call: "papa, papa, pa pa…", a call drawn out with Tsunamis: and a fading hail still echoing but having become a gentle tone to talk to me in the texture of my memory, ·······. I and others we offer voices to this ton e t o t h i s t o n e…or else you have not been ·······.

ヽ ヽ ヽ ヽ U,,na-saka is, *Hana* flowers of Prunus Mume,,,
fragrant on the waves, *Hana* flowers of Prunus Mume,—
ヽ ヽ ヽ ヽ A movement of wind,,, (of Makimuku ヽ ヽ ヽ Of a thousand
white peaches —
ヽ ヽ ヽ ヽ *Una-sa,k,ka's, Tamran-sa, k, ka's*, Inclination's peaches are an
incarnation—

JUN 20 2011 Lawson (blue) and a rusted-out train (red) were wet against the *côté* (s) of a hill,, those inner sea (a-Es), of mine had been dry-ed (······,clay-ed ······), tire-ed (exhaust-ed,,), ······, -ed, id, *saha, saha, saha,* ······ *From this planet, an enormous cascade rushes out perpendicularly* = Ru(-shes), ru-, ru, ······ was Valéry's imagination, *or*, the vision (or the view, ······) Valéry saw through Leonard or both,,, perhaps he so saw so —. *Sō-da* (yes), that Jocon-da 's tranquility was, ······ ominous and savage wind on its way to the

1. The other (part of) something, e.g. "the other voice" or even a revelation, a sign, of a parallel or alternate reality.
2. The reverse side or back of something, e.g. back of the hand.

When 背手 is read as *hai-shu*, the term mostly means the former, whereas *se-de* mainly signifies the latter. This is not, however, a fixed formula, because Gozo usually freights a single word with several meanings; any other possible interpretations derived from the combination of these two kanji characters would also need to be considered. For instance, 背手 also occurs in the thirteenth-century collection of koans assembled by Dōgen, *Shinji Shōbōgenzō*, where it suggests a haptic, rather than say, visual, perception of the unknown, a feeling of one's way toward something new.

/M-ai/ or /m(u)-ai/: my. Originally written わたくしの [watakushi-no]=I's, with emphases on the sounds *ku*, which implies 苦 (ku): pain; and *shi*, which implies 死 (shi): death as well as 詩 (shi): poetry.

/Mi/: "me" in English. On the other hand, the pronunciation /mi/ in Japanese mainly means (though it depends on which kanji is used), fruit, body, oneself, significance, and substance.

凸: a kanji character that means "convex."

Sumiyoshi-san: a popular name of Sumiyoshi Shrine, located near Gozo's apartment in Tsukuda. "-*San*" is usually put after a person's family or first name, meaning either Mr. or Ms., e.g. Gozo-san. Even though it is grammatically incorrect to do so, it is often attached to non-proper nouns.

"*The last book*": refers to *Naked Writings*, the book that contains the present excerpt, published in 2011. Gozo, at least when he decided to publish *Naked Writings*, was prepared to say it would be his last book.

"*Up came the dawn,,,*": a reference to the final poem Yosa Buson (1716-1784) composed, which reads: "*Shiraume ni / akuru yo bakari to / nari ni keri*" or "White plum blossoms blooming / the Dawn alone / is to come." Gozo has altered the words from Buson's original somewhat; he often, perhaps intentionally, does not quote correctly. The translation reflects Gozo's quotation.

collapse of universes, ⋯⋯ a subtle clicking sound when planets tip,,, *no -da* ,,, *no -da* ,,,. My lifelong friend Marilya-san with her, *sō* (yes), "we two, saw, ⋯⋯a door, ⋯⋯be-fore,," , , *sō la vie*, "oui ", we, saw, "two a door, ⋯⋯ ", *mita, mon, da,* (saw), (endings and entrances), (yes), *eh? Mino Monta?* ⋯⋯. Saha, tasa, ha, ⋯⋯. Ha, Sa, ha, sa sa sa, ⋯⋯

ヽ ヽ ヽ ヽ Lawson (blue) and a rusted-out train (red) were
Wet against the *côté* (s) of a hill—
ヽ ヽ ヽ ヽ Lawson (blue) and a rusted train (red) were
Wet against the *côté* (s) of a hill—

The light of *té*: hand of the *se* : back of an instant, ⋯⋯ gone grainy, ⋯⋯ like the grains,, (close up on a hand held close,,, up), on the back of,,, an instant, (behand,,, of an instant) ⋯⋯ a granular light,, ⋯⋯was, pro,b-a-bly ⋯⋯ b, b, p, something to do with pain,, pro,b-a-bly with b, pain *mo* (mo, mo-ther⋯⋯),⋯⋯ *se-dé,, yoru,,,* w-as,,, w-alking, to-w-ards, me,,, ⋯⋯

 s e - d é yoru
ヽ ヽ ヽ ヽ *The other hand,, a night,,,* w-as,,, w-alking, to-w-ards, /mi ： /, ⋯⋯

Utatsu-no-Kurasan (Kurayoshi Abe-san of Babanakayama the village of Minami-sanriku-cho in Miyagi prefecture), Utatsu-no-Kurasan,, and Ikuchan-san who had died *mo,* too, would have gone, so far, as to place candles atop their hats to write a starry sky, ⋯⋯ (yes, not to draw, ⋯⋯ but v.Gogh, wanted to write,, ⋯⋯). Van Gogh,, his, have and ☞, *wo,,* ; it was Thursday, June 15 2011, Jōsai (Tōgane), in the "Light of Se" (sounds like 'Light of House?' well,,,) my eyes should have seen Toru Takemitsu-san but on *the other hand* (⋯⋯ *the-other-hand,,* not *backhand,* but, could be, *the-back-of-a-hand:* behand) the back of the moment when,,, the *yuki-onnna* of Keiko Kishi-san's sewing hand, *wo,* to the space just above (of almost empty, ⋯⋯) was,, her right hand, *wo,* her hand was raised, when she raised it, at that moment, ⋯⋯,
 behand
the grains of the light behand a girl in the midst (of the-other-hand,,) of van Gogh's 'The Potato Eaters', leapt into my ☞,⋯⋯ Now, Utatsu-no-Kurasan, now Ikuchan,, and facing ruin, we must engrave this on our hearts (*hurts*), this, ⋯⋯, *this,* which I know long know I know to give a name, ⋯⋯

ヽ ヽ ヽ ヽ Arisen, rai (sed,-ed) d,, a Hand in the moment,—
 world-remained
ヽ ヽ ヽ ヽ /ai/ ☞-ed the Night!
ヽ ヽ ヽ ヽ U,, na-saka is, Hana flowers of Prunus Mume,,, fragrant in the
waves, *Hana* flowers of Prunus Mume!

(mo cuishle)
fuse: "my pulse," which Gozo writes as "脈-管." A literal translation would be "pulse-vein." But "fuse" is used here to maintain a textual dialogue with Dylan Thomas's "The Force that through the Green Fuse Drives the Flower," which Gozo refers to in another book.

(uni)
ウ二: sounds similar to 海(umi), "the sea," which is an integral part of this *Writing.*

Akigawa: the Akigawa River or Akigawa District. The river is a part of the big Tama River System west of Tokyo.

"papa, papa,,,": the call of a fisherman's wife to her husband who, unbeknownst to her at the time of her call, had been washed away by the 3-11 tsunami.

Tsunami: the tsunami that hit the Tōhoku region of Japan as a result of a massive earth quake off the coast on the 11th of March, 2011. In some places, such as Rikuzentakata, the wave reached sixteen meters in height.

(una) (saka)
Una-saka (海 坂): an imaginary boundary between "this world" and "the other shore," believed to lie beyond the horizon, according to the Kojiki and the *Man'yoshu.* A literal translation of *Una-saka* would yield something along the lines of "Sea-Slope," "Sea-Boundary" or "Sea-Hill," but maintaining the original Japanese here avoids narrowing down the layered nuances of the word. Shinobu Orikuchi (1887-1953), a Japanese ethnologist, linguist, and literary author, elaborates in *Man'yoshu Jiten,* or *A Dictionary of the Man'yoshu* (1919) as follows:

> (una) (saka)
> (海 阪): *"Sea's Hill," "Sea Slope," "Sea Arc," "Sea Border:" an imaginary slope or arc which ancient people, who were suspicious about the fact that ships were seen to disappear once they reached the horizon, conceived of. They imagined there was a slope or declination beyond the horizon and ships disappeared once they had reached its beginning.*

Makimuku: the Makimuku ruins. An archaeological site in Nara Prefecture dating back, it is believed, to the early third century CE. In 2009 researchers unearthed the remains of thousands of fruit stones in what is thought to have been a storage pit. Gozo was surprised and inspired by this news.

Lawson: a chain of convenience stores in Japan, easily recognizable by their cerulean blue signs.

In New Bedford at the entrance to the Whaling Museum, a wooded smell of midship cabins; Until in Herman Melville's,,, 🐋 until I f,o,u,n,d the 🐋 wo,,, ······ looking alongside van Gogh's night of candle stars where I had w,a,l,k,e,d, -ed ······ and had been walking. In a memo on Auden's *The Enchafèd Flood*, 2.7.1963 ······ it had been seen before; for this 🐋 to meet this 🐋,,, I'd walk the deep-path step by step,

de - a p - t h
night naught nigh non
fumu, fumi, fu,, /mu/, ······ a lifeline, ······ foretold to me (*un-mei* (Prov.), *un* (my), *-mei* (fate), ······). A sixty-years' road I've come ······ to disfigure (tear away,,) the ear that misheard Rikuentakata as *tekizenjoriku*, ······. /ai/ too at last in this way might be assumed to sing, ······ ; Thus I heard the voice—of a 山 hill ······.

ヽ　ヽ　ヽ　ヽ　Like this the voice (was, he,a,r,ed,,,),
　　　　　　　of a 🐋〰 hill (a caaaap, cap, ······)

Herman Melville wrote in the last line of the first chapter of *Moby-Dick*, "......*like a snow hill in the air*", a whale's soul like a hill of light (reflected sloping on the back of a hand:) was, ······ rising, ······

ヽ　ヽ　ヽ　ヽ　Rising (-ing, rising!),,,with (,,,out,,,)no 🐋,,, "*a*",
ヽ　ヽ　ヽ　ヽ　Thin,, Thread's,, 'th ······', (was, ······), be, ing , he, a, r, ed,—.
ヽ　ヽ　ヽ　ヽ　U,,na-sa,,ka is *Hana* flowers of Prunus Mume,,,
(Iku-chan,,,) fragrant on the waves, *Hana* flowers of Prunus Mume,—.

(Of my "*Pulling the oars shallow,* ······ ") on the Sandbanks of America (e.g. 'Brown's Bank' Charles Olson, *The Maxiumus Poems*, p22, L116-7) used to be,,,thought of as a way of "poetry writing", the depth a night contains, it's the-other-hand (*tsu, na, de:* a rope towing ······),was,e, mer, r, (/ra/!), g, ing, ······ un-a-void-a-bly/ e-mer-g-ed, ed, id, d,......

ヽ　ヽ　ヽ　ヽ　A white peach's(/mi ː / fruits, thousands,,,) thrŏw from where/there,
the *se-dé* of the night (*nuit*),,,
ヽ　ヽ　ヽ　ヽ　U (-niverse), mi (*me*), da (*yes*),,,　(Iku-chan,,,Iku-chan ······) , —

JUN 21 2011 To *Una-saka* (Sea-slope), to *Yomi* (an-other-world), led down descending roads, ······ whereas a 山 (,,shining,......) hill's,, thin,, slow,, Voice,, I was certain called out in,,,the language of whales (/gei/),,, we henceforth a thousand times again…, we, like the road of *shiho*, ······ (it's ha, ha,,,

Mino Monta: a Japanese TV presenter who is sometimes compared to Oprah Winfrey.

Yuki-onnna of Keiko Kishi-san: the former a role played by the latter in the 1964 film adaption of Lafkadio Hearn's *Kwaidan*.

Rikuzentakata: a city in Iwate Prefecture which is now known for the devastating damage it suffered during the 3-11 tsunami.

Tekizenjoriku: literally "landing in face of the enemy." A military term especially significant during WWII when Miho and Toshio Shimao (see below) met.

Yoshishige Yoshida: a Japanese filmmaker and friend of Gozo's.

Miho Shimao: (1919-2007) one of the most influential female figures for Gozo. Born and raised on Kakeroma Island in the Amami Archipelago, she spent more than twenty years mourning the death of her husband, Toshio Shimao, in 1986, occasionally writing stories and essays. She played the leading part of Aleksandr Sokurov's 2000 half-documentary film, *Dolce*.

Sea Quake: Japanese suicide motorboats used during WWII.

Nami-Ura: literally means "behind-the-waves" or "the-other-side-of-the-wave."

Masaki Horiuchi: a professor and Gozo's former colleague at Waseda University. Horiuchi specializes in American literature and his research interests include authors such as Herman Melville and Ralph Waldo Emerson.

石を一つづつ… : reads *Ishi wo hitotsu zutsu, aruhiha* or *hito-tsukami zutsu*.

Heigo Asahi: (1890-1921), an ultranationalist and assassin who killed Zenjirō Yasuda, an entrepreneur who founded Yasuda Zaibatsu and was the great-grandfather of Yoko Ono.

Eureka: a Japanese monthly literary journal published by Seidosha that specializes in contemporary literature. Apart from its regular monthly issues, the journal publishes three or four additional special issues per year. The "Genet special" (January, 2012) that Gozo mentions was one such issue.

M (-other), too), remember -er, -r, ru, ru, ko to, da (yes), ⋯⋯, A night of white blossoms (a noon, none,,,)
and white-peaches, ⋯⋯ in New Bedford, Massachusetts ⋯⋯ . And finally already ("ready?") ⋯⋯
"setts" echoed in,,de Utatsu-no-Kurasan, in his voice (de,,, da, ⋯⋯)

 White peaches thousands,,, where—.
ヽ ヽ ヽ ヽ Moonlight shivered, slivered on ⋯⋯('s, ⋯⋯reeds', ⋯⋯) a door to the
👁 (/ai/, ⋯⋯) zat,, th (z, ⋯⋯) -r-ow-s (z), ⋯⋯
 White peaches thousands,,, where—.
ヽ ヽ ヽ ヽ Moonlight shivered, slivered on ⋯⋯('s, ⋯⋯reeds', ⋯⋯) a door to the
👁 (/ai/, ⋯⋯) zat,, th (z, ⋯⋯) -r-ow-s (z), ⋯⋯
ヽ ヽ ヽ ヽ The color of a peach the color of a Peach (each, ⋯⋯) zat,,, whispers
Revolutions! (⋯⋯), from maelstroms—
 O, Oh, there,,, Thus these words first slipped and drowned ⋯⋯
⌒ the hill's 👁's weary whale was
 as a daughter to it —
ヽ ヽ ヽ ヽ The color of a peach the color of a Peach (each, ⋯⋯) zat,,, whispers
Revolutions (⋯⋯), at a /gei-t/ in the night,—

That,,, 👁, in it too (da,,,), and Melville's "Starbuck, let me look into a human eye; it is better than to gaze into sea or
sky, ⋯⋯ this is the magic glass, man; I see my wife and my children in thine eye" (—And so Starbuck, let me look into
a human 👁. It is better than gazing into the sea or sky, ⋯⋯ a human 👁 is the mirror of magic; I see my
wife and children in your 👁. ⋯⋯) This mirror wo ⋯⋯, behind the mirror, to go there, da (yes), ⋯⋯;
JUN 22 2011 Thus, perhaps,, almost, close to,, the thin tremble of a sob, ⋯⋯ and of a sob
dwindling (diminishing, ⋯⋯), the inmost voice between the mind and voicing, ⋯⋯. And my old
age (shying, ⋯⋯) heart made /mi/ say sotto voce a moonlit silver, ⋯⋯ but I still or more than ever don't,,,
know what, a,i, am trying to set right, ⋯⋯. I know I've worn a candle atop my hat and tried to write a
starry sky,,,, like van Gogh like Pushkin like Mandelstam ah yes like Nietzsche too, ⋯⋯ da (yes), ⋯⋯ I
know I've been blinded,, stretching my hands to find a blow upon a double-pipe of ancient reeds,,,,
frantically ⋯⋯, and I know on my skin the tsunami's scar calls back in reverberations (and vibrations
to the double-pipe ⋯⋯ And yet to other fine pipes,,, buried, too, but not so deeply—

ヽ ヽ ヽ ヽ Another beautiful pipe buried but shallower still.

 Sū-chan—

Mariko-san Asabuki: a former pupil of Gozo's at Keio University who won the 2010 Akutagawa Prize for her short story "Kikotowa."

Hoppō Bungaku (Northern Literature): an independent literary magazine published by Genbunsha in Niigata Prefecture. Its contributors include Kiwao Nomura, Shuntaro Tanikawa, and Jeffery Angles. Issue no. 65 (June, 2011), which included some of Gozo's work, was an anthology of poets' reactions to the 3-11 disaster and the Fukushima meltdowns.

Shoshi Yamada: a publisher in Tokyo specializing in poetry, art, philosophy, and literature, with whom Gozo has published eight of his major books including *Quiet America*, *Quiet Place*, *Boat of Death*, and *Naked Writings*.

PUNCTUM TIMES: a news magazine launched in 2006 by Issei Teramoto in Tokyo. Issue no.15 (July, 2011) featured Gozo's "Requiem" later republished in *Naked Writings*.

"Poetry-writing," *taskikani*: certainly, resembles a certain embroidery, ······no, or needlework,, or at its *côté (s)*, like someplace near a sewing box, ······. But be that as it may, why, having left New Bedford (after three nights' stay, ······), around 11:00 yesterday with Marilya-san, ······having welcomed Yoichi Yoshihara-san (with the red bicycle, ······) from Tokyo ······, when headed for Concord with him, ······ when we had breakfast,,, *why* should I so abruptly come to a "line" like this, ······? The pipe was Pushkin's and another of van Gogh's brushes, ······. There, sitting in a too-cooled corner of the Hotel (residence Inn Marriott) in New Bedford no, not for poems in a book, not like needlework, ······ but, say, something that might be like a "premonition" an effect from a hidden source,,, the whole of what "poetry-writing" meant might have been changing, ······. And, supposing,, the "whole" progress a being in becoming,, (or, as it were, like a being) walking in search for somewhere like an 'artificial garden', ······ this "beautiful pipe" would be a sign (sigh…n) re-sounding in it, ······. But given our generations' differences, ······ given her nickname, "Sū-chan", Yoshiko Tanaka-san, might have appeared due to a lingering effect of lightness, ······ of the air with subtle frangrance that struck me when a while after her death… she who was so painfully anxious for those who suffered in the wake of the tsunami… she who lay dying in bed…I learned that '好' was the derivation of "Sū", ······. I looked up to recall a scene from the film 'Black Rain', a film based on a novel, a novel by Masuji Ibuse, in which she, having been,,, not knowing so,,, exposed to radiation from the Hiroshima bomb…all her black hair fell out; she combed her hair out in handfuls, ······ (I'm ashamed of my,, such a naïve expression,,,), to pull away her own remembrance; and this response of mine too, it lay under the "line" ······. And were it possible, on 2011.7.15, when I arrived at a public lecture with Yoshishige Yoshidasan, I would, I hoped, remember to mention, ······ that the clue to deciphering his 'Women in the Mirror', might be found in Sū-chan, ······: and this intution, ······ akin to a ray, a stream, a stream of light from the moon ······(I hesitate to name it 'moonlight', ······), might have lit the world ······ in place of *ashes of death* ······.

、 、 、 、 And so beautiful a pipe buried but shallower still.

Sū-chan—

······ "Ashes of death" is a reminder of Miho Shimao-san, (with Toshio Shimao-san, an officer aboard the *Shinyō* ('Sea Quake'), sitting in a sandy place near Kakeroma-jima): Toshio was a young lieutenant; he sat with his legs outstretched while Miho-san, in a *kimono*, (probably full-dress), settled down next to him. She knelt on the ground in the formal *seiza* position, ······. Then when I spelled out 'ashes of death', the hand holding the pen I wrote with, as if guided by an-other-hand, slanted a little, JUN 23 2011 At six in the morning I saw Yoichi Yoshihara-san, who came all the way from Japan for a day of rain. Concord, off to Boston (Logan) with Marilya-san, having promised a hot meal at the coming year's end for the four of us,,, with Yoshihara-san and his young wife,,, in a corner of the deserted

hotel (Best Western Concord) café,,,, at once,,,, as I returned to lines of poetry I'd continued to write for days, ······ lines really no longer of 'poetry', ······, or as I began to deeply understand silence,,, the silence of Shinobu Orikuchi after the Great Kanto Earthquake, or silence as a means of support, a guiding splint for a healing hand,,, silence led my hand when I wrote out "ashes of death," ······(from Hiroshima to Fukushima),,, ······ or, as a dream more real than dream, like the one I'd had this morning: Satoshi Ukai-san had suggested I cut myself (karada or kuchi) into pieces. The dream, it had a delayed effect, ······, or as the revelation of an invisible, hand, ······(Captain Ahab's whale-bone steps across the deck, ······) as if this were the incarnate theme of poetry, ······ I saw it suddenly at the head of most of the lines I'd written, or it had just then appeared: A sign recited like a psalm,

A sign chanted to the tides of a psalm

ヽ ヽ ヽ ヽ ヽ ヽ ヽ (with the tide of poetry's of, ······) "A",,,
ヽ ヽ ヽ ヽ ヽ ヽ ヽ (Ahab's belabored steps, ······) "A",,,

"A" token (sign) was, take, -ing, shape ······. So are Kana letters which appear when I speak most honestly ······. Per, ha,(ha!), ps ······, here, like an insect or an "animal" -al, l, l,,,, the trace (vestige), of a stone (thrown), of some hand or some manner of clumsiness cast by a (shy (ing…)) writer, was, up,, ap, p, ear, -ing, and ······, the way, ······ the water coursed (mainlined, ······), was just written down, ······ per, ha, ps, ······, per, ha, ps, ······. Or, aru-hi-ha, na, mi, da, (waves or teardrops), ······, the alternating soles of water ······ in water's steps ······.

ヽ ヽ ヽ ヽ Or, aru-hi-ha, na, mi, da, teardrops, ······ the sole of water, its footsteps,
na/mi/-Ur behand the waves, (white peaches', Mume prunes' ······), extends Una-saka

JUN 24 2011 For Emerson (Ralph Waldo Emerson), (on 10.Dec.1936—which was, surprisingly, during the latter period of our Tempo era, ······) who stayed at Walden Pond, there was the following scene, ······ and the scene's tone (its sights its sounds), lingered in my imagination, ······ the rain that night of the gozoCiné was, it so happened, proof, ······ since I saw, next morning, ······a sort of play or musical-composition-like Emerson's telltale gestures, or the tone of a gesture, and vividly across the raster of what I see ······, something leading to Tōkoku Kitamura, to his 'Theory of Inner Life',……and, yes, to Nietzsche too,,, ······ and so I was convinced, ······. Next time, it has to be in harshest winter, I will come back to this pond with the collected work of Sakutarō. My green card, I presume, would be—since I must seem suspicious by now—probably, ······, invalidated, ······. Emerson's diary entry for 10.Dec runs as follows " ······At Walden Pond, I found a musical instrument which I call the ice-harp. It's a thin

coat of ice covered a part of the pond but melted around the edge of the shore. I threw a stone upon the ice which rebounded with a shrill sound, & falling again & again, repeated the note with pleasing modulation. I thought at first it was the 'peep' 'peep' of a bird I had scared. I was so taken with the music that I threw down my stick & spent twenty minutes throwing stones single or in handfuls on this crystal drum."

ヽ ヽ ヽ ヽ Stones single, or aruhiha, handfuls—da (yes),,, na, no, da (yes) ······

Under "handfuls" of stones, ······there is a house of fairies and on winds that grip the world in "handfuls" they play music and it is a house for the dead there under the stones unaware of each other there are separate hourses for the dead under the stones ······and, oh, such performances are there,, Or, *aru-hi-ha*, acts, or scenes, to be performed unrehearsed, ······ Isn't it, Mr. and Mrs. Gander, (Mr. Forrest Gander) — I wondered while showering in a heavy rain ······ yes this "while" is important, ······ yes, "as ······ing" and the "-ing" of Beckett's *Waiting for*—, like Beckett, and "ヽ ヽ ヽ ヽ" like my own waiting,,, each is a stone to itself, *Isn't it?* Throughout the night, keeping "ヽ ヽ ヽ ヽ" close in my mind, in my hotel, where I poured over an essay on Emerson written by Masaki Horiuchi-san, "Leave him alone, Defend him from yourself", and so the essay's "leave him alone" or "leave him or her to be"
<small>ishi-wo-hitosu-zutsu aru-hi-ha hitotsukami-zutsu</small>
became the basso continuo of Walden Pond, ······ "石を一つづつ、 あるいは ひとつかみづつ" translated "*stones single or in handfuls*" in English ... In a heavy, battering rain, I asked Mr. Forrest Gander to wear a white raincoat (for protection from X-rays?), and just like Heigo Asahi, counting *roku, sichi, hachi,* six, seven, eight, ······ walked toward *him*, while I, holding a cocoon in my hand, an I, a holder, no-k-no-wing what it meant, ·······. Now I know: the cocoon was a vague manifestation of Emerson's stone, or something suggestive of casting, or one stone taken for many "in handfuls", ······. In that place I played a recording (CD) of 'A Weaving Girl,' a mandolin piece composed by Sakutarō, on the 'lake' shore of Walden Pond and it might have emanated from the cocoon. There was the first line of Mr. Gander's 'After Hagiwara', "*A child was pulled from the lake*" was, ······*sō-da* (yes), *sō-da-rō* (yes, perhaps), ······ the "lake" was Harunako ······ or a whisper from the direction of a lake pronounced like a woman's
<small>spring-girl</small>
name—*Haruna-ko* ·······. Some surprise when Mr. Forrest Gander said this lake was deep, ······,was
<small>behand</small>
part of yet another, another hand touching a moment <u>behind</u> its time when, ······ the voice of deep water, not just Basho-san's "*in an old pond*",,, was what I heard ······. JUN 25 2011 After a dream of that third night in Concord, ······, since obdurately repeated, an image of afterbirth enveloped in white paper, this to the dreamer,,, /ai/ have been wondering, ·······. An after-birth might exist for the memorable. 'A Day of Years' End' by Ryunosuke Akutagawa, who hid himself in the guise of an I hauling a cart of afterbirth up a steep slope in Tokyo, devoted in his steps to the sound of a depth suggested in Sobe and Kadena, names that call up 'water roads.' Contented I saw the next morning ······ with the
<small>passage</small>
passing ☙ of a migrating bird that this 'naked writing' was drawing to a close. Only a half-page more to go, ·······. Ah,, and Fuchimā,, in the form of (something like) strands of seaweed or sticky reads, was

tangling there, ⋯⋯. In other words in short ⋯⋯. 'An afterbirth enveloped in' a ripple caused by this sentence was beyond doubt, ⋯⋯, at the very core of Emerson's 'stones single, or in handfuls', ⋯⋯ per-ha (ha!)-ps, ⋯⋯; thus I realized and thus I found an abyss ⋯⋯ was lying there. The depth of Mr. Forrest Gander's 'this lake is deep', too far the depth /ai/ have come to descend and here I plunge I sink with poetry with music ⋯⋯

In Fuchi-mā (an afterbirth (which used to be a blazing tree, ⋯⋯) a universe is entering, is enveloped in white ⋯⋯), In So-be

It may be ⋯⋯ this 'enveloping white ⋯⋯' betokens sex, ⋯⋯ and was perhaps already ("ready?") a path to an old pond, revealed by Mr. Gander who was a teacher of Auston Stewart who in no time translated my *Goro Goro* despite its many difficulties into English, ⋯⋯. Having come as far as Concord, this naked psalm began to reveal ⋯⋯ its innermost self ⋯⋯.

ヽ ヽ ヽ ヽ The depth of Walden Pond ga-thered the g-race of Sobe, ⋯⋯
ヽ ヽ ヽ ヽ Cast stones single, or in handfuls, upon *Una-saka*,—

A poetry adrift upon the waves of,,,
A poetry adrift upon the waves,,,
of, A poetry adrift upon the waves,,,
of, A poetry adrift upon the waves,,,
of, A poetry adrift upon the waves,,,
of, A poetry adrift upon the waves,,,
of, A poetry adrift upon the waves,,,

JUN 26 2011 This at last for a writer or a writing hand only half a page is left to epilogue, ⋯⋯. Or, *aru-hi-ha*, incessantly wringing the hands until this point this is what the psalm has asked of me, ⋯⋯. What explanation can I offer for its request? Narrow a path a path that conducts its travelers to bottomless old ponds ⋯⋯. On 3.11 2011, when the massive earthquake rocked Tōhoku, an ill-thought-out or to-date unsucessful piece I'd been writing on Jean Genet lay on my desk. The deadline for the special Genet issue of *Eureka* had already passed, but my own Genet piece didn't cease from progressing; it was out of respect for Genet, I think ⋯⋯. My experience of the 3.11 incident, having attended an event for 'Mariko Asabuki-san' just before that, this psalm, then, this psalm gained a

swiftness as if all in one breath. I reached out to Yukio Mishima and published 'Blue Sky: Quiet Void' in *Hoppō Bungaku* and this time met my deadline ······. So, 'Blue Sky: Quiet Void' has undoubtedly helped to shape this book. Four decades after the publication of *Quiet Place* and *Quiet America*, Shoshi Yamada of Kazutami Suzuki-san, Fumiyo Oizumi-san and Tetsutaro Nakamura-san, is due to publish this book as a conclusion to those earlier pieces ······. Issei Teramoto-san of PUNCTUM TIMES has put forth a tremendous effort in backing its publication. I may add that *gozoCiné* has been coming along well ······. I realize, having written that previous line, that this book is to be a companion to *Goro Goro*, which was first published seven years ago. That being the case, I could hardly ask anyone but Hiroshi Nakajima-san, who designed *Goro Goro*, to design this book ······. I would like to express my deepest sentiments of gratitude to Takeo Yatate-san, who allowed me to use the title 'Naked Writing' which, otherwise, he would have stowed away for some future project between us,—. I do beg the reader's pardon—, for the many waves, cresting and breaking, that left these words behind. My hope is that the book is read with all the turbulent motion and emotion that brought it to be; it is like waterlogged newsprint washed up on the shore—.

"here, this narrow road, where does it lead?
Té, -n, -jin-sama, over spheres, this narrow road traverses spheres,"

Poetry is (soaked is drowning) a way to a pitch-black Perpetual World
 is
Peaches, peaches, golden peaches white peaches
Blind turtle blind turtle— ⌒⌒ the universe repeats upon your back,,,
﹅ ﹅ ﹅ ﹅ Stones single, *aru-hi-ha*, handfuls,
—Ever each season a season in afterbirth after the living ······ (left after birth,,,,th) th,,,, *no, da, yo*

throw them
to the sea
I foresee,,,
no "good or bad" fortune
but wheather or not there is song.

———

: TRANSLATED BY SAYURI OKOMOTO AND DEREK GROMADZKI
Sections of *Stones Single, or in Handfuls* previously appeared in *Boston Review* and *PEN America*.

Translator's Notes

―――

This text is a poem, a performance script, commentary on a film, and contains rememberings, quotes, and responses to *100 Children Waiting for the Train*, a film by Ignacio Aguero, portraying the filmmaker Alica Vega as she engages impoverished Chilean children in the art of filmmaking. Yoshimasu's talk followed a screening of the film, as part of an ongoing series of discussions on film and poetry held at the Athénée Français in Tokyo, Japan. Transcripts from Yoshimasu's talks were collected in a book 燃えあがる映画小屋 (*Film house in flames*) (Seidosha, 2001), from which this piece is taken.

Borrowing a Melody* from the Hearts of the Three Graces**

(Athénée Français "Film House," second installation. June 21st. With thanks to Alicia Vega, from all of us)

———

<<When a dog [CACHORRO] passes under a frame [コマ] of paper [カミ]. I SAW the Three Graces of Film [メガミ] [CINEMA], smilING>>

"The eternity of waiting for the arrival" of a train is connected like a band [OBI] to "The eternity of watching the departure" of a train, the knot on a band [OBI] of beautiful lacquer [MAKI-E] ,……,

that which passes [スぎる] under [シタ] the obi [オビ], "the shadow [カゲ] of a small, white, happiness [シアワセ]," ……

"Style"*** [Griffel****] —perhaps we are circling quietly around [MAWARI WO] a "flower."
I moved closer to certainty, with a premonition that I would one day understand

Three-thirty, it appears that the eye of the typhoon is passing nearby
The quietude of "Lullaby for Birds, Insects, Fish"**** — by Fumio Kamei
It was a quiet that layered the blindness of the typhoon and the blindness of my heart

The portrait of young Christ had also been put away, and I was listening to the voice of a distant, crackly [KASURETA] mic check, "one [uno], two [dos], three [tres],……" and why, why do the little birds know the beginning, the beginning of quietness. Is it not the case that "the hearts of birds" also begin with "no" or "no not even once."

A voice letter from Alicia Vega arrived and I went to the Hachioji post office to retrieve it

The small pack~AGE~ (コマ) of the frames of film is pretty

(From Nobuyoshi Araki I learned, to tilt slightly, I had begun to take photos, peering in)

Comes through, still. When you tilt the frame, the neck (コマ) the nude self (ハダカ) grows
pathetic
 (ウマ) (ハダカ) 、、
 Horses are nude (THE RUBIES, ARE VERY, BEAUTIFUL......)

 (シタミチ)
Comes through, still. I wonder what kind of small roads under the shadow of
white happiness (シアワセ) "The Spanish language dog" walks

 Gabriela Mistral
"For the amber people "
What can I say, and how
 Dylan Thomas, poet from Wales
"For some reason I have been transformed into a bird"—famous words from the later years of Fumio Kamei
"The chirping of small birds" = "the green blood vessel of my heart" = the
事 koto、事 koto
clickety sound of "old films,"
 (According to the musical notes, "kew" is the song of the owl)
I hope to write brilliant words like Yukio Mishima, in old, dream-like characters

HOU-OU (Imaginary bird considered as an auspicious bird in ancient China)
鳳凰台上
鳳凰 遊ブ (plays)
鳳去ツテ (leaves)台空シ (emptiness)
江自流ル(flows)

 (Poem by Li Taibai, while regarding the handwriting of Yukio Mishima......)
(Referring to plants. Thus called because they grow upside down with their necks to the ground) ("Marquis de Sade")
("Confessions of a Mask")
Tilt/ anatropous/ a light that shines from a different direction/ devoted to this
 "Kinkakuji"
("peephole"······) "the key to the space between the internal and external"
and its"sound/ creaking," your innocent eyes, that departed from it,....../
were those of a great painter

"For the amber people"
What can I say, I had the slightest feeling that I was one of the "amber people,"
 (ガリ)
as I cut a stencil, smelling the pencils of slate and metal,......

73

I spread out the *Vision* of a thin film like a screen, and with long eyes, — ^(I watched it)
the secret to breathing, I am certain, is in the phonetic soundings

An empty ^(TAKO) kite, —
"To the amber people"

Comes through, still and even more. When tilting the frame, the ^(コマ) neck ^(クビ)
my ^(ハダカ) naked self grows pathetic. Horses are ^(ウマ) naked ^(ハダカ) (THE RUBIES, ARE VERY, BEAUTIFUL)

If I had grown up listening deeply to *a mi* Niño ^(MISTRAL) or *de* Niño, ^(ALICIA)
 "Becoming a body that finds difficulty in dwelling upon the same branch
 ^(TOKOSHIE) ^(MS AKIKO YOSANO) for all eternity–leaves and wet leaves"
 has been something that is no longer to be spoken of

But, you see today I pick up one single fallen leaf. It's like a ^(コマ) frame of
paper from a film,
 ^(マタ) Again, seated, the ^(HONOKANA) faint ^(HITOKAGE) human shadow, that is "myself"

Alicia, I'm envious of such a beautiful sweater, and the underlay (for shoe
polish), ^(burning grains) I mumbled

"Ghosts are so, passé,"

Did I hear the ^(NIWATORI) chicken crying?!
 From ^(EGAO) smile to ^(EGAO) smile, the Coca-Cola ^(BIN) bottle feels ashamed, · · · · · ·

You were looking straight at it, "the beginning of the 'film,'" the beginnings
for ^(SOREZORE) each of the ^(SEQUENZAS) "small gatherings"

I just learned that for Mr. Mekas to film as if he were dancing meant that film
is a ^(オビ) band of eternity
And then, ^(マタ) again, one sheet, ^(マタ) again, one sheet,

Long, gray,......"I stood still for another line," saying "I am a line of deception!"

Having feared "Small beginnings," —I felt like I was beginning to understand the thinking of the Council of Chilean Film, who deemed it appropriate only for those above the age of twenty-one

Dear Alicia,—

The way the wooden classrooms of the población [low-income housing] are bathed in the extreme radiance (of lightning, and the Andes, a little damp, again [マタ], dries, the light repeats [マタ]) is, very.

Very is muy bien?

The old [コ] violin, too, reminisced about its homeland [FURUSATO], sang of it,......
And then
That
Kite [TAKO],—
Dear Alicia, —
Thank you [有難度う].

In thanks, I would like to fill a large bus, to the brim, with peaches [モモ], and send it to you. Filling the spaces with our impoverished hearts.

Gracias [グラシアス]

** "The Three Graces"—from "The Dead" in James Joyce's *The Dubliners*. In a speech given during a Christmas Eve party, Gabriel refers to "the Three Graces of the Dublin musical world." Also with John Huston's great work, one day, "in this Athenian film house"......Our "Three Graces," here, are Alicia Vega, who sent along a message all the way from Santiago; Gabriela Mistral, likewise a

very dear and important poet also from Chile; and Akiko Yosano, from whom this writer was inspired to attempt to write in this form. * Add to that a "Melody" according to the composer Toru Takemitsu. *** The day after the first "Film poem" event, I was doing a talk for the first time with Masaki Tamura, famous as the cameraman for the "Sanrizuka" series, "Nipponkoku Furuyashikimura (Country of Japan—Village of old houses)," and "2/Duo," that was to be in the republication of *Eiga Geijutsu* magazine. I was mumbling to Takeshi Shono, the moderator, that he should read the Celan translations by his father, Kokichi Shono. And so then it was that I was re-reading Kokichi Shono's translation of Rilke and Paul Celan. "That single word, *stylus* (Griffel) in the final section strikes a bolt of some strange, cruel feeling in me. Sharing the same Latin roots as *graphic*, the word *Griffel* also carries the meanings of slate pencil or carving knife, but in form it seems to be somewhat similar to the Old High German word *Graf* (to grasp). And yet the thing that deeply impressed me was the strangeness of the sound of this word…"…I was rereading this, and quoting it. Stylus, slate pencil, metal pencil—writing implements not dependent on sumi or ink. The fact that we attempted to gather and make in a single night this mimeographed copy that you hold in your hands today is perhaps connected to this idea of a "pen that does not come through" or "the strange creakings of the pen that does not come through." **** A "posthumous" work, created after a silence of twenty years, in his later years (He died in 1987 at the age of 79). "For some reason, I was recently transformed into a bird" (Fumio Kamei). ***** Gabriela Mistral "Lonely lips sunken voice/ my knobby knees embarrass me/ You are here right now/ I feel sorry for my naked self (Translated into the Japanese by Masamichi Arai). ****** *Anthology of Golden Age Poetry* (first published in *Bungei*—May, 1969) Around dusk last night as I was writing this text, the fax started up, informing me of the wake and funeral of Taro Kaneda. For a while I was just stunned, recalling the memory of this excellent editor, this dignified, high-spirited person who I owed so much to. The final two lines of *Anthology of Golden Age Poetry*. I wrote them standing on the train to Ochanomizu, and hurried so that I could hand it over to Mr. Taro Kaneda at Kawade Shobo, which was then located in Surugadai. Yes, Taro Kaneda was also the editor for Toshio Shimao as well as Yukio Mishima (the following day at the wake, I confirmed this with Hiroshi Terada. I had made up the part about him being Mishima's editor. However,……postscript.) I hadn't seen him these last two or three years. By writing this, while praying that he rest in peace, I hope that I might possibly be repaying him just a little bit in this poem—is the small thought that came upon me (6.21. '97, 10:00 A.M.)

: TRANSLATED BY SAWAKO NAKAYASU

Translator's Notes

The original title of the great Yasujirō Ozu film *Early Summer* is *Barley Fall*. In this case, "fall" refers not to autumn but to the time when barley is harvested—early summer. "Barley Fall" is also a seasonal haiku word for summer. In a fortunate typographical coincidence that matches the visual play of kanji, English depicts the double l's in "fall" and "small" as images of stalks of barley.

The Ozu movie takes place in Kamakura in early-mid May and the summer sea breeze is discernable. The poem begins with four nostalgic images: barley, the sky, a bookmark, and dogs. These set the stage for the poet's attempt to hear the voices of the dead—voices from the other shore—which, despite the fact that they are inaudible, are registered through an attentive tuning to signs. It is interesting to note that when Gozo mentions "writing a poem of a whistle (from the other shore)," he is using the term "詠む (*yomu*) as the verb "writing," but literally *yomu* means "to read or chant out loud." In its doubleness, then, the writing of a poem is also a "listening to the inaudible."

Parentheses have at least three roles in this poem. They add referential information to phrases as in: (from the Other Shore). They also suggest ways of reading certain kanji, as in: 栞 （しおり） Bookmark. And parentheses can offer variant possibilities for reading kanji. For example, in the line 上の空 （うわのそら） the parenthetical phrase lets us know that the first phrase, 上の空, reads as *uwa no sora*, meaning absentminded, deep in thought, abstracted. But Gozo inserts "ruby" (a small letter, *furigana*) above the character 上 so that we read it as "ue." *Ue no sora* means "sky above." Consequently, we end up processing two simultaneous meanings as though we were hearing stacked chords in music: "deep in thought" and "sky above."

Throughout "A Whistle from the Other Shore," Gozo seems to be trying to recreate the breezy air of early summer in Kamakura (west of Yokohama) and to fuse it with the happiness he derives from revisiting scenes in Ozu's *Early Summer*. The film itself has a happy ending, and no one suffers or dies (although one might imagine that the old couple who remains at the end doesn't have many years left). The poem's emotional register, its expressive happiness, may be closely connected to a comfortable awareness of the constant nearness of death and the dead. Certainly, when we watch a film (especially an old film), we see the dead rise. Perhaps Gozo's dialogue early in the poem with Miho Shimao, the famous writer of the autobiographical novel *Shi no Toge* (who died in 2007),

80

A Whistle (from the Other Shore)

(Athénée Français "Film House," second installation. June 21st. With thanks to Alicia Vega, from all of us)

———

—"Saying that what he wanted to capture was the sight of wind blowing and trash whirling in a midday deserted alley in Singapore, Ozu kept the camera fixed low in that alley for two days." (Osamu Takashi, *A Dazzling Shadow Picture* p 406–407). The figure of Yasujiro Ozu "peeping into the camera every time he comes back" (so vividly depicted) persists in my imagination…

On the morning of November 25th, 2003, during the leisurely last revision of my dialogue with the writer, dear Miho Shimao (Ronza January, 2004)
Ears of barley

The dear Yasujiro Ozu encountered skies…yes, those
High in the sky (miles away)

As though casting a glance at the skies, something precious, pressed against distance
Bookmark

the dog-eared pages of memoranda and diaries like branches snapping across my mind
Shadows of puppies
The pale shades
of their mutual
happiness

(SCRAPPY and S and *His Dogship*. And dear Wakabayashi…And *His Dogship* contentedly trotting along the seashore in the opening scene of *Early Summer*. The four puppies loping down the backstreet, a dirt? alley after an evening shower…, how many times have I counted them…)

The sign's letters hand-written by dear Ozu himself, "Hirayama Clinic, right down this ditch"
Left behind like bookmarks in other books, to reveal their fragrances

Told by Professor Seori Takahashi from School of Political Science and Economics at Waseda University that dear Yasujiro Ozu wrote those letters himself
The sound of how I turn the pages of cinema has been changing

is an attempt to raise the dead, too. In Japan, there are many superstitions concerned with whistling as a means of making a connection with the spirit world.

Finally, it's significant that Gozo uses forms of speech that lend personhood to things such as the shadows of dogs and the letters that Ozu hand-writes on a sign.

To pause there without being able to pause there—going back to pause, and going back to continue, dwelling in the eyes or pupils of Grandmother and Mother dear Chieko Higashiyama and dear Chishu Ryu is

The sound of wind through carp-streamers in the May sky, high in the sky (miles away)

The face we tried to make out in dear Noriko's apartment room in *Tokyo Story*, the face of dear Shoji "looking dazzled", his ears of barley coming clearer …

"Soundless barley under the fall wind at my pillow"

The haiku by Buson and, *in the mind's eye* of dear Chieko Higashiyama, there is "Chekhov's crane" which danced up to the Ainu elder, but I've known this "scene" for a long time. It is the wasteland I've begun to walk. Yet dear friend, we will continue on through the Dying …As a small i. A white i. "Maya, I realized at that instant, had ceased breathing …" her mother dear Miho told me of how little Maya lived, how she died …

"To die—without the Dying / And to live—without the Life"

Though the poem by Emily Dickinson accompanied our *dialogue* as an epigraph, it was Professor Masaki Horiuchi who made me aware that

The small d of die and the small l of live are

You see, talking with dear Kiju Yoshida, the lonesomeness of Ozu films and his partner's full-hearted exuberance are found in such places as a whistle,

Ears of barley

Wednesday, November 26th, 2003, off the shore of Hayama? Zushi?, while writing a poem about a whistle (from the Other Shore),

A whistle (from the Other Shore)…

plunged—*ears of barley whistling … whoosh*— into the depths of my earless ears while I was writing

Ears of barley

And at the *whistle's* call, four puppies loping down the dirt path of the passage, somehow I,

So humbled

Second by second a new *habit* forms, I'm learning a new way of life second by second, frame by frame from the cinema (frame by frame from Ozu), ... this is how the passage begins to create, to recreate. In *The Dazzling Shadow Picture: Yasujiro Ozu* by dear Osamu Takahashi, reading the description of the teacup wrapped in the palms of dear Chieko Higashiyama in the last scene of *Early Summer*, I had to take a new look at the scene at once, again,

A teacup, embraced, weeps

As if, you see, taking a suck from something inconceivable or from a narrow passage, an abyss in her belly ...

A teacup, embraced, wept

———

: TRANSLATED BY KYOKO YOSHIDA & FORREST GANDER

Forrest Gander Interviews gozoCiné (Take 4)

———

FG: To be honest, I'm not sure I understand *gozoCiné*.

gC: But why would you want to? To *stand under* some definitive scaffolding of its meaning? What would such films have to offer then? Maybe *gozoCiné* is just an ongoing experience, realized through the contours of perspective, that offers itself to you.

FG: That's not so clear to me.

gC: Clarity. We moon after it as though it weren't art's least truthful construction. But most of human experience is palimpsestic. We hear one conversation over others. Unrelated events, memories, fragments of language and image play constantly in the background of every act of our attention. Rebounding between the rocks of an old wall are diminishing but unextinguished sound waves of the voices of the wall's masons and of people who walked the path beside the wall talking to each other in low tones. This is the material comprising the soundtrack of *gozoCiné*, the cries of love and exhaustion, the silly songs of children, all the collective hullaballoo of those who came before us, those who made brief claims against oblivion and are gone. One approach in art is to focus on clarities, but it leaves out so much. Because *gozoCiné* isn't interested in those kinds of clarities, you begin to look for a different kind of clarity inside yourself.

FG: Still, the films have themes, no?

gC: By negotiating topographies charged with presence and by tuning the viewer to the trace and hiss of events that took place there, *gozoCiné* challenges conventional transactions with time. One film occurs on a barren mudflat where hundreds of people, carried off by a tsunami, once lived their lives. In another, the camera circumambulates a tower of imagination constructed during an epoch of violent upheaval in Los Angeles. But the films are interactional, incorporating the improvisatory given.

FG: What improvisatory given?

gC: Every landscape in *gozoCiné* is raked by *uchu no shitakaze*, cosmic wind. So the film is less a statement of intentionality than an act of reception.

FG: But what kind of commentary is the film making about those places? For instance, Gozo sits on a windy mudflat and says some words or hammers a mark onto a scroll. Nothing much happens.

gC: The signal thing is that Gozo commits his body to the place itself. He is physically there like an antenna scanning for place-memory and sensitive as well to his own influence and interaction. There is nothing abstract about the film. To commit your body to a place is to begin inhabiting the world. Gozo's radical gambit is to offer himself to a landscape in complete openness and without any preconceived goal. His whole body becomes a listening. In some ways he is acting out a prayer if we think of prayer as total attentiveness.

FG: But why use a warped lens?

gC: The camera effect you notice generates more than one image at once, so the technique foregrounds the temporality of perception. Also it suggests the presence of more than merely observable phenomena.

FG: Like ghosts?

gC: Perhaps.

FG: And what about the weird thumb-light?

gC: Don't you think it dramatizes the point of view? It insists on the presence of the viewer by marking one end of the depth of the visual. Gozo doesn't pretend he is not there either. That the scene simply presents itself. In *gozoCiné*, all seeing is an engagement. Nothing is presented passively.

FG: I tend to remember specific images, say the daffodil wagging in a storm or layers of leaves buckling upward and the sound of footsteps, or the face of—is it Melville?—superimposed over a whale's eye. But I have less of a sense of the narrative arc of the films.

gC: Maybe because the narrative isn't decided, even after the film is made. Instead of a plot, the film follows traces. And it absorbs interference along the way, welcoming it. Did you know that Gozo carries cowry shells when he travels? He uses them—*takara-gai* in Japanese—in many of his performances. Although audiences sometimes assume they are fetish objects, the cowry shells are connected to folkloric histories of the origin of Japan, of ancestral sea voyages from China to the country of islands, of northern migrations, rice cultivation, the roots of Japanese spirituality. Carrying the shells, Gozo takes on the role of sojourner. He follows the trace of his ancestors. But his encounters are always in the present tense. They are always unscripted. So a *gozoCiné* can happen only once. And each occasion leaves a residue or remainder of indeterminacy that, after a while, ignites to initiate the next *gozoCiné*.

III.

Translator's Notes

———

Kadena 嘉手納 is the name of a small town west of Okinawa City. Its dominant feature is a U.S. air base—in truth, the largest military base in the Far East. It takes up 83 percent of Kadena and requires its population of 14,000 to live in an area of a little over one square mile. (One third of the Okinawa Island is taken and used by the U.S. Air Force.)

The poem is mostly written in a combination of kanji and katakana, the syllabary used today mainly to express foreign words and onomatopoeia, though during the Second World War and before, the combination was used for official military communications. In the translation this is shown by italicization.

"Kadena" is included in Yoshimasu's book, *The Other Voice* (Shichōsha, 2002).

Ampo Hill: a low overlook with a sweeping view of Kadena Air Base. The word Ampo is an abbreviation of the *Nichibei Anzen Hoshō Jōyaku*, the Japanese name of the Japanese-United States Mutual Security Treaty and immediately evokes the Ampo Struggle, in 1960, the greatest anti-government demonstration mounted in Japan's modern history. It was in opposition to the renewal of the treaty, signed with the San Francisco Peace Treaty in 1951. The renewal was accomplished despite the huge riots.

Utaki: a small, simple structure that enshrines a family's ancestral deities in Okinawa. It is usually built in a wooded area. The word originally appears to have meant "a safe place." In the past, a vestal offered prayers to it and chanted the deity's song during a festival.

Katakata: an onomatopoeic word that means "clattering." Later on Yoshimasu morphs the word into *katakana*.

…air striking a rock: This could also mean something like "it may have been as though the air struck a rock."

"An Upturned Gem": a phrase that appears in a passage in Book III of John Keats' *Endymion*, where occurs a description: "…a youthful wight / Smiling beneath a coral diadem, / Out-sparkling sudden like an upturn'd gem, / Appear'd," etc. Junzaburō Nishiwaki (1892–1984) famously used the phrase in one of his early poems, a tercet. See Hiroaki

Kadena

———

Kadena, Kadena,
thy name is, Kadena, —

The instant I stood on Ampo Hill, and had an entire view of Kadena Base
something popped inside me,
the landscape had popped,
Low hills, foliaged hills. The *utaki* of Hamakawa-san's ancestors is moving
In the Kadena Base something has started to move clattering
Something had started to move clattering
It, may have been the sound of the fire of an oar
Or perhaps it, may have been the heart (feeling) of the air striking a rock

Ura (cove), Uruma, Ura (cove), Uruma
Kumpon, Kumpon, Uru, Uruma
Uru, Uruma, Ura (cove), Uruma
Kumpon, Kumpon, Ura, Uruma

That moment, my heart (feeling) may have had forgotten "English"
Yeees, for a long time, I had had forgotten "English,"
"English" no longer, has, "the power of silence,"
"An Upturned Gem—the glitter of a gem lying face up, like a log,"
The wing-beat of Kumpon of the loneliness of the edge of the universe was reaching my ears,
Kumpon, Kumpon, Uru, Uruma

Kadena, Kadena,
thy name is, Kadena,—

The waves of Hamakawa-san's heart turned into a "song (*ayago*)" and created a
　　corner in my heart, that was certain
Kadena, foliaged hills, low hills,
narrow snakes and *narrow* pigs, seemingly enjoyable lonesome travel routes,

Sato, tr., *Nishiwaki Junzaburō: The Modern Fable* (Green Integer, 2007), pp. 12-13 and p. 31.

ayago: Okinawa word for "song."

narrow snakes: may allude to Emily Dickinson's poem that begins "A narrow Fellow in the Grass / Occasionally rides—/ You may have met Him—did you not / His notice sudden is—."

Uchibanari: place name, "Inside-apart."

Yūbanare: place name, "Evening-apart."

Saigyō-san: Saigyō (1118-1189) was a warrior-turned Buddhist monk and a constant traveler, who was counted among the greatest poets in his lifetime and ever since. Stories, legendary or otherwise, began to be told about him before his death, and less than a hundred years after he achieved nirvana, *The Tale of Saigyō* (*Saigyō Monogatari*) came into being. Among the poems grouped as "110 tanka on love" is *Kokoro kara kokoro ni mono o omowasete mi o kurushimuru waga mi narikeri*, "Making my heart brood on things because of my heart, I torture myself, my own self."

Tiānmù (Tenmoku): iron-glazed tea bowls that Japanese students of Zen brought back from Mt. Tiānmù, in Zhè Jiāng, during the Kamakura Period. Also, any tea bowl.

Clatterin', clattering, —, the heart of a "song (*ayago*)," was reaching my ears,
 from the wave/back (ura),
clattering clat
clopping clop

Encountering Uchibanari, Yūbanare (both are elegant isles of South Island, Uchibanari is the external
 isle of Iriomote, and Yubanare, that of Kakeromo),
 my heart was beginning to ex – foliate
Ampo Hill's, Uru, Kumpon
Ampo Hill's, Uru, Kumpon
Katakana's clattering, the shoulders (kata) clattering, the body (karada), shaking
 it, calling
Family member or family member, or, clattering clat, clattering clattering,
 a diving fighter's machine guns echo,
Ampo Hill's, Uru, Kumpon

Uru, Su'u, I couldn't, had had known, the "Man'yogana,"
couldn't, have had known, "words," but then, why pouncing, why is the heart,
 why is it pouncing,

Why is the heart pouncing, why is the heart pouncing, just like a tree being in
 love with a tree
Or, it, may be the attribute of, "the matter called the heart,"
Is matter the heart's true nature? *Saigyō-san,* —
Why is the heart pouncing, why is the heart pouncing, just like a tree being in
 love with a tree

Kadena, Kadena,
thy name is, Kadena, —

Under the eye of NHK TV, Takahashi Ryō-san's camera "why is the heart
 pouncing, why is the heart pouncing,"
"Kadena, Kadena, *(line-breaking)*

thy name is, Kadena, —" *so, I was going on to write,* . . .

when I was beginning to notice that the base was going away from me, —Inside-apart,
 Evening-apart,

both the universe and the isles, are lonely, so saying
I was beginning to notice that they were parting, —

Inside-parting, Evening-parting,
tree leaf, Tiānmù (Tenmoku),—
Kadena, Kadena,
thy name is, Kadena,—

———

: TRANSLATED BY HIROAKI SATO

Translator's Notes

————

Yoshimasu Gozo wrote *Koishii aigō* (恋しい哀号 "The Keening I Long For") following his travels to Okinawa in the fall of 2002. Among the place names he mentions in the poem, Koza is the former name of Okinawa City. Futenma, in Ginowan City, has been, for some decades now, the locus of the most tension resulting from the U. S. military presence in Japan. The larger matter of U.S. rule in Okinawa, in fact, dates from before the U.S. occupation ended with the Peace Treaty in 1952, although Okinawa officially "reverted" to Japan in 1972.

The U. S. Marine Corps base in Futenma that Yoshimasu talks about in this poem takes up a quarter of the city's land area and is its prime space, hindering people's movements and blocking proper city planning. A fleet of attack helicopters permanently stationed at the base creates noise that often necessitates suspension of teaching in schools, among them Okinawa International University.

The latest round of upheavals involving Futenma started with the rape of a teenage girl by a U.S. marine in 1995. The following spring Prime Minister Hashimoto Ryūtarō, whose uncle was killed in Okinawa, began negotiations on the removal of the marine with U.S. Ambassador Walter Mondale. Since then, a succession of prime ministers has tried to work out a solution, all in vain, ending, most dramatically, in Hatoyama Yukio's resignation as prime minister with tearful apologies to the Okinawa people in 2010, despite his pledge to solve the problem of the U.S. military base in Futenma. That was nearly eight years *after* Yoshimasu wrote "The Keening I Long For."

In this poem, as in others, Yoshimasu plays with word associations that are made possible partly because of the abundance of homophones in Japanese and partly because a range of Chinese characters (pronounced the Japanese way) are available for individual Japanese sounds. Yoshimasu advances these sound associations sometimes through the deployment of the Man'yo syllabary (万葉仮名), a set of Chinese characters selected—at a time when Japan did not have an indigenous writing system—to represent Japanese words. They are used sometimes for sound, sometimes for meaning.

To cite an example in this poem, Yoshimasu applies two characters in the Man'yo syllabary: one meaning "pretty" in Chinese (美) and pronounced *mi* in Japanese, and one meaning "bean" in Chinese (豆) and pronounced *zu* in Japanese to create the Japanese word *mizu*, meaning "water" (水).

The Keening I Long For
Walking in Koza, Futenma (Fuchimā), Okinawa

———

Sibilants (stem sounds) started (*threading through hogosu, hogusu, Tuft-Spew-Section . . . are unfastened,*
untangled, unlaced—stitch, Middle English *stiche*, from Old English *stice*, sting.)

ꞩꞩəu s‚(ɐɥɐu) punoɹᵷ ᵷuᴉɥsᴉɟ ∀

, (fishing ground (*naha*)'s nets, na · *m̃a* (*wa*, rope . . .)'s *wa*,

 san's
Grandma called "Nui (Sew)" elegant skill (scheme),—November, "Black
Musashino's",

white pheasant (shirakiji), waterfowl (kaitsuburi, scratch-diving), I myself "hold my
breath long," the one diving (from Middle English *diven*), YO (give), GO (apple), RE (zero),
TA (many), (left dirty , goes on

sinking-clearer)

swan (kō), stork (kō), white pheasant (shirakiji), waterfowl (kaitsuburi,
 —sinking-clearer "so long," feathers, begin to grow, tap "the compound
 (*Gelände Celan*)," with their beak

Anzel (*Ancel*), clapper rail, is the bottom (soko) of the water (PRETTY-BEAN) cold,
 Froid?

Early fall of the year 2002, "summer dust" (just), dancing, falls, the former name
 Koza, . . . (Bearded Seat, . . . Old Apologies,

. . .) now Okinawa City (enter it from Central Park Avenue, the second house to
 right) Teruya Rinsuke Teruya, Terurin Inn, why was I standing in front of
 it, . . . KE (eat, hair), MO (mother), NO (field), JI (dye) (mi) TA (paddy), . . . that I myself do
 not know, *ha* (leaf), *na* (vegetable) (ha, na,), like a flower standing, may well
 have been ("The Origin of the Deer Dance" of . . .)

To indicate what he is doing, Yoshimasu deploys a variety of type sizes, including "ruby," the 5 ½ point size which the Japanese printers adopted in the second half of the 19th century to give proper readings to (mostly) Chinese characters.

At times, where Yoshimasu plays with Japanese, I try to re-create the effects by playing with English. For example, in the first "stanza" of "The Keening I Long For," where Yoshimasu plays with Japanese sibilants, *shion no shigen*, etc., I substitute "sibilants (stem sounds) started," etc.

Re-creating most aspects of Yoshimasu's semantic, orthographic, and typographical play in English by using the roman alphabet is well-nigh impossible, to put it mildly. The most that the "translators" can do is to suggest a semblance of what Yoshimasu is trying to do. To ascertain exactly what he might have in mind with each of the semantic, orthographic, and sound associations, the translator must ask Yoshimasu, but the poet will likely answer, "I just don't remember"—as he did when asked to recall and describe which book(s) impressed him the most among those he read when he was twenty years old.

With allusions and references, I have noted only those that are obvious and clear to me.

The original poem appeared in Imafuku Ryūta, ed., *Ekkyō no bungaku* (Iwanami Shoten, 2003), pp. 261-278.

Tuft-Spew-Section: appears to be a place name.

kaitsuburi: grebe.

YOGORETA: dirty, soiled.

KEMONO-JIMITA: beastly.

Shika-odori no Hajimari (*The Origin of The Deer Dance*): a children's story by Miyazawa Kenji (1896-1933). The narrator, dozing in the middle of a field, hears from the winds how the local deer dance started. A farmer named Kajū, once traveling through this field, rests to eat his lunch but, too tired, he can't finish the last horse-chestnut dumpling and leaves it for the deer. He walks away but then realizes he has forgotten his towel. Going back, he finds a small herd of deer prancing in a circle. As he watches closely, he sees that they are eager to get the dumpling but are frightened by the mysterious white towel lying by it. One deer after another timidly approaches the towel, sniffs at it, and prances away to report to the other deer what he thinks it is.

Hand-wiper (viper) shaped like the *ji* (character) of *ku* (suffering), like the snag stitch
of the stem of the thread in "the pale-faced guard" (Miyazawa Kenji), that that
was a wraith (ray)

Was certain

(The eatery's second son the master had seen through it. I'd left some of the ham in the Okinawa dish
Gōya (bitter lemon) *Champur* uneaten on the rim of the plate. He saw through it. I'd been seen
through it.... But the thread of the stem of my heart was drifting as far as "where the fountain is"
in the barbed wire of Kadena Air Base. I was making my own forbidden realm. Made a forbidden
realm,...

My eyes, the eyes of a wraith (ray), being silkworm-eating (chewing mulberry leaves,
meaning the mouth of Princess Silkworm, meaning, mean, min...), can't be seen through
...I think

a bird pheasant white, a white pheasant (shirakiji), a stork (kō), a waterfowl (kaitsuburi),
has begun to prattle a mysterious language (meaning, mean)....

("I go to Kadena I go to Kadena, *ha* second gate....")

"Second" that, I can't forget for the rest of my life. I'm a B-class bird. I destroy
the word *komando* (command, from Late Latin meaning *entrust, hand over*), HO (tuft), RO
(watch-tower), BO (mother), SU (nest),... "I" is not "I"

B-29 *(B-twenty nine)*, B-29 *(B-nijyuku)*, B-29 *(B-twenty nine)*
Is "B" *Boeing* I wonder or is it *bomber*
"Two," and "nine"
"B" was, fragmenting, falling toward me....

Out of the crack (craze) of a death's-head (human skull), a fish (io), was, peaking,
and here, the number, is being

numbered

I, may have been numbering...

The pale-faced guard: in the Miyazawa story, the first deer hazards that the towel is a living thing, a "pale-faced guard (*aojiro no banpê*)" to protect the dumpling.

HOROBOSU: destroy.

HOKOROBI: frazzle, fray.

KOWARE: collapse.

HOTSURE: stray as in "stray hair."

KANGAETEITA: was thinking.

gossama: could be translated as "Thanks for the great meal."

TSUBUYAITEITA: was mumbling

Hagoromo, (Feather Robe), is the most frequently staged in the Noh repertoire. A fisherman named Hakuryō (White Dragon) one day finds a feathery robe hanging on a pine tree on the beach. He takes it as a rare find but discovers soon enough that it belongs to a heavenly maiden who has flown down to bathe in the sea. At first, he refuses to return it to the maiden but when she says she won't be able to fly back to heaven without it, he relents and says he will give it back if she dances in the sky for him. She does this as she gradually flies away.

HIBIKU: reverberate.

ghara ghara: may be a reference to Sanskrit.

minuma: the orthographic play suggests "while I wasn't looking."

"scratches" left in it: a possible reference to Mishima Yukio's statement that he wanted to leave a "scratch" on the earth with his literary work before his death.

life's frazzle, HO (tuft), KO (old), RO (watch-tower), BI (compare), . . . just, at the stem of my
heart, its collapse), KO (ten thousand), WA (split), RE, (zero) . . . , KO (ten thousand),
WA (split), RE (zero), . . . , death's-head (human skull), death's-head (human skull), and,
HO (tuft), KO (old), RO (watch-tower), BI (compare), and, HO (tuft), TSU (metropolis), RE (zero),

gōya, gōya

Old Apologies (ko, ja), Kōza (Old Seat)
Old Seat (Kōza), Old Apologies (ko, ja). . . . I came as far, and was thinking. . . .

Quietly (sinking-clearer), the fish (io) was thinking), KA (flower), N, GA (painting), E, TE
(hand), I (residence), TA (many). . . . (to me too, the hand and the hand-wiper (serge). . . . through O-

kinawa and Polynesia, the smell above and below (uheshita) the fish (io), is continuing. . . .

The taxie in Amami, a fish (sakana), which came up the quay side of the old
harbor of the harbor town, fin (hire) waving (furu), I, hand waving (furu),
ray (ei), orca (shachi)?

Gossama (gossamer), gossama, heaven's table for small spiders, the keening I long
for, the keening

Sibilants (stem sounds) started (threading through hogosu, hogusu, Tuft-Spew-Section. . . are unfastened,
untangled, unlaced—stitch, Middle English stiche, from Old English stice, sting.)

A fishing ground (naha)'s nets

, (fishing ground (naha)'s nets, na · ma (wa, rope . . .)'s wa,

"OWO"
"STING"
"B"

"OWO"
"STING"
"B"

Grandma called "Sew (Nui)" elegant skill (scheme), —November, "Black
 Musashino's", heaven's,

table for small spiders, the keening I long for, the keening I long for....

 a white pheasant (shirakiji)
 too
 so

cry(ing)
ain't it
it's sing song

crying
(one after another *yes*)
so, it's sing song

At *"Club Manila Boy"* at *"where its entrance is,"*
 a young soldier sitting (*orosu*)
in an Alpaca striped turtleneck sweater,
in the twilight on Gate Central Avenue,
 is melancholy (sinking-clearer)

one, three, four, five, six, seven, eight
A, C, D, E, F, G, . . .

A white pheasant (shirakiji)
 , when sleeping
 , what
 , does he use for a pillow, . . .
 ,"what, for a pillow...."
 this,

is a question (toi) continuously asked since primordial times,"
 , so was mumbling, TSUBU (grain), YA (roast), I (residence), TE (hand), ITA,
 the soldier, I,

the state (kyōchi), of my (watakushi no) heart (kokoro), that's, a swamp (nu), space ("ma" or "ma"),

soko (bottom)
 , *is bright*
 , Pretty Swamp (*Minuma*)
 , Pretty Swamp (ninuma)

 heart (*kokoro*)
 's
 plain (*pyonteku*)
 base (*kichi*)
 Pretty Swamp (Minuma)

 Pretty Swamp (Minuma)
 Pretty Swamp (Minuma)
 heart (kokoro)
 compound (Geigande)
 base (kichi)
 Pretty Swamp (Minuma)

A carrier-based aircraft, a monoplane, thud tok tok tok tok tok. . . . ,
Tachikawa, a wooden two-storied house, when targeting it it nose-dived, . . .

I had, my body sunk in the "swamp"
 , Louisiana, beautiful land
 , in Louisiana
 , a live-oak tree
 , he saw, a line of *Walt Whitman's* poem, in my memory

at its bottom turned into an elm (nire) its sweet bark, tap the bark with a palm
 (with a hand), nirekamu (fauna & *flora* ruminating, . . .)
was
that
thing's sound (to), heart's depth's elm tree chewing KE (hair) (sorry, Hatano Bunpei-san,
 Hatano Bunpe-san, of *The Literary Realm*, Hatano Bunpei-san, . . .)

along with
that
sound (to), sinking-clearer my body,

as though devouring, the core of an apple, of an unheard-of cosmos,

a whittled (kezutta) flower (hana), and, a poem sheet (tanjaku) that didn't get wet with
 ink (sumi), like this, in the sky (sora),

begin to dance in a thousand fragments
and surprise my heart

future ma (space), numā (swamp), mā (space), numā (swamp), Futenma (Fuchimā)'s,
 Camp Foster's
 bark it becomes

The Feather Robe (Hagoromo)'s, the loom (hata)'s sound (to), quietly (sinking-clearer),
HI (compare), BI (ditto), KU (only), to the core (shimu) of my heart, . . .

Ah, the keening I long for

 Futenma, —is brightly shining under the cloudy sky, and
 wasn't it, that I'd come here to bury a song

The crane-pick (tsuruhashi), delivers, my beak (kuchibashi), to the "fish" (na) at
 the bottom of the sea,—

 "two"
 "B"

"The fishing ground (naha) is a good place, far and near," the voice, I was
 looking at, intently (clearly),
only the tides' language, just one hometown, Old Apologies (koja), Old
 Seat (koza)
you can go any place you like, and can come back from there, that's all
like a B-29, that has never landed

was slapping the bark of a cherry tree, the palm (tenohira)'s, afternoon light,
 to go back to it, , , ,
"The past becomes all quotable," I don't think, but dropped, , , ,
the branch-break concerns me, one, three, four, five, six, seven, eight, where,
 did I drop it, , , ,

io, uo, na

bana, na, bana

, Hand Storage (dena), Apologies Storage (jana), Hand Storage (dena), "storage (na),:
what color is that? Scarlet (ju), Orange (mikan),

"Storage (nā)," is it not a fish (saka) na, I wonder,
On November 14, 2002 (Thursday) I visited the Okinawa City Library's young
lady (Kana-san)'s, name tag, I recognized

and was talking to her, but
"Storage (naa)," "Storage (naa)," may have been "a distant, faraway fish (uo)"

Water Storage (misuna)....
Or "mi" of "orange (mikan)" it may, have been....

B-52 (B-*fifty two*) B-52 (B-*fifty two*)
"B," *Boring?* or is "B"*bomber?*
"two," "five,"
"B," in the innermost part of my heart, were falling onto my heart in
fragments....

one, three, four, six, seven, seven, eight
one, three, four, six, seven, seven, eight

Goya (Bearded Hut), *Koza* (kōza)
when
I go out of it and leave *ghara ghara*

Sunna-ghara
that sort of thing may happen
I go out of it and leave *ghara ghara*

Primordial antiquity, even in *that* sort of country, wasn't the roar of aircraft
 resounding boom boom, forgetting
that, an angel lived for a while surreptitiously (with a rustle), to manufacture his
 wing-beat is the task of poetry
 when we know that, you see

Goya (Bearded Hut), *Koza (kōza)*
when I go out and leave *ghara ghara*

while I was talking to New Fence (Arakaki)-san of the Taxi, the swaying of my
 heart went on to become deeper and deeper

Kadena *Ka-dii-na*, Kadena *Ka-dii-na*
Air Base Kadena is, still singing, is still singing

Futenma *Marine Base* long long ago, the prickly fence, that I hadn't
even seen

looks like a "bookmark (shiori)"
and dis (mado) turbs my heart. We
thus

turning a "bus window" (mado) into a "heart"
, are moving, aren't we

 B-52 *(B-fifty two)* B-52 *(B-fifty two)*
 is "B" bomber? or is "B" Boring?

"two" and "five" bomber and
"B", were falling down fragmented. . . .
True Anger (manu,), Pretty Swamp (minuma)
Pillow (makura)'s kerchief (serge) and cloth (gin)
, whatever happened to *them*. . . .

Both our "heart" and our "word", are sinking-clearer, . . .
along with a white pheasant (shirakiji)
pecking (tsuibamu) at them, whom I met on the way, I walk into a distance

When the cosmos ends, will it recognize, some of "scratches" left in it? If it
doesn't, that will be
all right

Out of the crack (craze) of a death's-head (human skull), a fish (io, na), was, peaking,
and here, the number, is being numbered
The color
is

brown

A fishing ground (naha)'s nets

, (fishing ground (naha)'s nets, na · ʍɑ (wa, rope...)'s wa)

Sibilants (stem sounds) started (threading through hogosu, hogusu, Tuft-Spew-Section... quietly (sinking-clear-
er), unravel...)

———

: TRANSLATED BY HIROAKI SATO

Translator's Notes

───────

In the two poems selected here from Yoshimasu's 1998 book of poems, *"Yuki no Shima"* *aruiwa "Emily no Yūrei"* (「雪の島」あるいは「エミリーの幽霊」, *"Snowy Island or Emily's Ghost"*), Yoshimasu's visit to Iki Island overlays that of the great folklorist Orikuchi Shinobu, described in the 1927 essay, *"Yuki no Shima,"* (雪の島). "Emily's Ghost" refers to Emily Dickinson's poem that begins, "The only Ghost I ever saw / Was dressed in Mechlin—so —." In his notes to the poem, Yoshimasu makes both references clear: he quotes passages from Orikuchi's essay and the first two stanzas from Dickinson's poem in a Japanese translation.

Iki, an island in Tsushima Strait, north of Saga (part of Nagasaki), was called, in ancient times, Heaven's Single Pillar, *Ame no hitotsu-bashira* 天一柱, most likely because it rises out of the ocean in relative isolation. The name Iki (壹岐) was once pronounced yuki, as the two Man'yogana Chinese characters 由吉 in the *Man'yoshu* (poem no. 3694) suggest. The old name, which is homophonic with "snow," is something Orikuchi confirmed, in a way, with a man in his sixties, a knowledgeable gentleman with a long white beard he found himself with aboard a boat to Iki. As Orikuchi wrote in the essay, however, the "snow" association may well have been prompted by the name of one of the rocky outcrops surrounding the island, one called *Kanashiro-se*, 金白礁, "Gold-White-Reef," which, in the evening light, was covered with "powdery snow"—the guano of "sea crows," common murres. The word *iki* is also homophonic with "live," "living."

Orikuchi's essay refers to the folkloric water tricksters, *kappa*, that inhabit almost all parts of Japan. On Iki, legend has it that a kappa once transmogrified itself into a woman, mated with the lord of a mansion, and gave birth to a child. But as soon as its true nature was exposed, it jumped into a well (or river) and went back to the sea. This is what the maid of the inn where Orikuchi stayed told him. He goes on to tell a complex legend about kappa on Iki, adding that similar stories are common throughout Japan, including the Ainu story about the nymphs called *mintsuchi*.

In the second poem, *Tada hitori aruku, shikō no / yūrei no yōna chikara* (ただ獨り歩く、思考の / 幽霊のような力, Walking All by Myself, my Thought's / Ghostly Power), Af(h)unrupar is an Ainu word meaning a dent or an entrance that is said to lead to the netherworld. There are a number of so-called holes on hillsides and such in the northernmost island of Japan, Hokkaidō–some of the better-known examples are in Noboribetsu, northeast of Muroran. These holes may be vertical or horizontal.

Snowy Island or Emily's Ghost

———

"Hey! Where on earth are you going?"
—Stopping his rotary tiller, the grandpa said accusingly.
The grandpa could only have been what, in last night's dream, had imitated
 the figure of a crane, all tail, with beautiful struts:
 the Ainu old-timer.
The figure of a crane with beautiful struts stopped work and talked to me.

"Hey! Where on earth are you going?" , a mysterious voice with no luster
or rust.
And, "This fall why do I feel so old: in clouds a bird," the owner of that voice.

I came back, October 28, I stayed up late into the world-stay (night),
dreamed of stealing
Is it the embodiment of a crane the figure with beautiful struts,
or is it the figure of the grandpa, the grandpa's rotary tiller
The old repairman removed the cooling cap radiator cap and cried, "The water,
well, you had just one last drop of it left,"

A number of times, in the shadows of the path michikage of the dream, yes, as if
to place "a small table,"
unless you get close
 there, you won't come
 face to face with life
 no, you won't, I see

"We stand and part," thus on the ridge between paddies azemichi "in my
dream" I might have met
"time" that was

Some of Yoshimasu's poems have extensive footnotes, but here there are no footnotes, and the translator has provided all of them. In these translations and notes Dickinson's original poems are cited from *The Poems of Emily Dickinson, Including variant readings critically compared with all known manuscripts*, edited by Thomas H. Johnson (The Belknap Press of Harvard University Press, 1951).

"Snowy Island or Emily's Ghost" won the Education Minister's prize in 1999.

The title poem has a note citing Emily Dickinson's poem, with a Japanese translation, which begins:

The Only Ghost I ever saw
Was dressed in Mechlin—so—
He had no sandal on his foot—
And stepped like flakes of snow—

rotary tiller: a plowing machine, usually the size of a somewhat large lawnmower.

Ainu old-timer: the association of cranes with the Ainu probably comes from the fact that the Japanese habitat for the *tanchōzuru*, the red-crowned, is now limited to eastern Hokkaidō, and Hokkaidō has been strongly associated with the Ainu for some time now.

This fall why do I feel so old: Kono aki wa nande toshiyoru kumo ni tori. One of Basho's last haiku, composed in the last year of his life, the 7th year of Genroku (1694).

I stayed up late ...: here Yoshimasu employs Man'yogana for "night" (*yoru*) and "stay up late" (*fukashi*). To "translate" the three characters for *fukashi* would be meaningless, though the translation of the two characters for *yoru* is forced and of course meaningless, too, to put it mildly, because Man'yogana are supposed to mostly represent sounds.

We stand and part: the opening phrase of one of the *Hyakunin isshu*, "one hundred tanka by one hundred poets": *Tachiwakare Inaba no yama no mine ni ouru matsu to shi kikaba ima kaeri komu*. The poem, by Ariwara no Yukihira (818-893), relies on puns, as most classical tanka do, but in its essence says: "We part and I go to Inaba, but I'll return if I hear you wait for me."

parting
with me
A sheet,
 in the form of autumn,
 had stopped, and, was nodding

———

: TRANSLATED BY HIROAKI SATO

yūkage: the same word is used by Orikuchi.

made a twirl: this perhaps echoes Dickinson's poem cited in the next poem, which has the line, "I burned my Being round and round."

Translator's Notes

————

terrifying: the word reappears toward the end of this poem.

itana: most likely a family name. The first *itana* is the verb-ending of a sentence. The others are associational puns.

Zaō: volcanic mountain, 1,841 meters (5,523 feet) high, that straddles Yamagata and Miyagi prefectures. The deity Zaō Gongen is enshrined at the top. Its old name was *Wasurezu no Yama*, Mount Never-Forget. Today it's a famous ski resort.

Sokolow: the spelling is not ascertained.

Mount Moon: Gassan 月山, a volcanic mountain 1,984 meters (5,950 feet) high. Tsuki-yomi-no-mikoto, the deity of the moon, is enshrined at its summit. Basho wrote: "On the fifth day we paid our respects to Gongen. It is not known which period the Great Teacher Nōjo, who established this shrine, comes from. The *Engi-shiki* says it is a shrine of Ushū Sato-yama. Did the scribe mistake the character *kuro* for *sato* and call it *sato-yama*? Did he abbreviate Ushū Kuro-yama and call it Haguro-yama? I'm told that the *Fudoki* says that the name Dewa derives from the birds' feathers used as an annual tribute from this province. Along with Gassan and Yudono, it makes up the 'three mountains.'" (*Basho's Narrow Road: Spring & Autumn Passages*, tr. H. Sato, Stone Bridge Press, 1996, pp. 97-99).

I turned my Being round and round: the second stanza in Poem No. 351 reads:

> I turned my Being round and round
> And paused at every pound
> To ask the Owner's name—
> For doubt, that I should know the Sound—

Many cloud peaks collapse . . .: from *Basho's Narrow Road* (p. 101). The original *hokku* (called haiku today) is *Kumo no mine ikutsu kuzurete tsuki no yama*, which, to be grammatically faithful, means something like: "How many cloud peaks need to collapse before Mount Moon reveals itself?"

Walking All by Myself, my Thought's / Ghostly Power

———

On the road to the AFUNRUPAR [ahun-ru-par] = to the "AFUNRUPAR formed as
 I hadn't even imagined" (Research Reports on Northern Cultures, 11th Issue, March, 31st Year
 of Shōwa)
I had started walking all by myself perhaps because of the power of just one
 word "only"
Blade of grass (as terrifying as,.... the wraith of a word's ending....) ly-lily,
 language's spirit's
stalk forming "an invisible beautiful curve" (Chiri Sachie-san, James Joyce) which in the
 footpath of my imagination (Ms. Mayama Taka-san et. al., Itako-san)
made flowers bloom itana,...blowhole itana, ...bowhead isana (Dr. Mashiho Chiri),...
 blowhole itana,....

Why is (the entrance = solitude)
(Am I trying to walk past the road par) in me,
 (or am I just passing by it,...) Drooping his head
a wooden buddha in rags or something like that,...giving a sidelong glance at
 the beautiful lightly made-up top of Zaō from the window of Hotel Castle,
next to "Sokurov's crane," without giving a side-glance "walking past / passing
 by,"
"This is B-class,..."

I walked up to the window, peered out, and was listening to the mysterious "n't" in "You've
 learned A for B, have, n't, you,...?"
which "beautiful Zaō" smiling whispered
unable to pronounce it,....
In the window of the bus heading to the airport, "ru," "ru," ru,"....floated up
 "Mount Moon"
May have been the figure/form like the ghost of AFUNRUPAR
That in me too, there was a street "ru" like this of the universe,... was surprised

And then—I started—too: in Emily's poem, a hyphen and then a stanzic break follows "too."

Upon my Ankle: in Emily's poem, it's "Ancle" not "Ankle."

No one He seems to know: in Emily's poem, "One" is capitalized and "seems" is "seemed."

And bowing with—a Mighty look—: the Japanese translation misses or ignores "bowing," which Yoshimasu picks up.

At me—The sea withdrew—: Poem No. 520, published in 1891, was given the title "By the Sea." The poem begins:

> I started Early—Took my Dog—
> And visited the Sea—
> The Mermaids in the Basement
> Came out to look at me—
>
> And Frigates—in the Upper Floor—
> Extended Hempen Hands—
> Presuming Me to be a Mouse—
> Aground—upon the sands—
>
> But no Man moved Me—till the Tide
> Went past my simple Shoe—
> And past my Apron—and my Belt
> And past my Boddice— too—

Orikuchi Shinobu (or Nobuo, 1887-1953): a famous ethnographic interpreter of Japanese literature and a poet. The tanka, partially cited, reads in its entirety:

> *Kuzu no hana fumishidakarete, iro atarashi. kono yamamichi o ikishi hito ari*
> 夏の花　踏みしだかれて、色あたらし。この山道を行きし人あり
> Kudzu flowers trampled upon, their color fresh. Someone has taken this mountain path.

It is included in *Umiyama no Aida* (*Between Sea and Mountain*), published in 1925: *Orikuchi Shinobu Shū* (Kadokawa Shoten, 1972), p. 309. Orikuchi is one of the few tanka poets who experimented with punctuation, spacing, and lineation. Yoshimasu has written a

Let's do something, yes, let's dance like this, like Emily

(*Watashi wa jibun no seimei o ryōte de furete mita*
 I felt my life with both hands
(*Soko ni aru ka dō ka tashikameru tame ni*
 To see if it was there—
(*Watashi no tamashii o kagami mi chikazuketa*
 I held my spirit to my Glass,
(*Motto hakkiri sasetakute*
 To prove it possibler—
......

(*Guruguru jibun no sonzai o mawashite*
 I turned my Being round and round
 (Toshiichi Niikura-san, *Emily Dickinson*——*Fuzai no Shōzō*,
 published by Taishūkan Shoten, p. 18)
She really turned round and round didn't she Emily
"Many cloud peaks collapse and the moon over the mount" (Basho-san) The old
 gentleman's (and his slowing counting eyes) voice....
I proved..., by myself, isn't it?

"Collapse and, *possibler*,..." We, too, "stack" new word/s, and "tilt" them
E(SachiE)h?, a dead dog supports the Moon Mountain, his legs stretched out
 side by side, ...? ("On Wakabayashi Isamu," by Mr. Shin'ya Koizumi, Yamagata Museum of
 Arts, October 23, '97)("The Moon and Immortality")
Somehow there's a smell
 of rubbing (rasping),
 the universe becomes aware of
Probably, collapse
 and ballooning (possibler)
 "Silver Heel,"
 I wish the Sea of
 Japan had a name like that,
Emily's ly, "Silver Heel," Sachie Chiri-san

whole book describing his travels following the steps Orikuchi took in ethnographic explorations, *Shōgai wa Yume no Nakamichi* (Life Is Midway in a Dream), published by Shichōsha, in 1998.

Ainu's Crane: "Between Sea and Mountain" opens this way:

> "Hey, where are you going!"
> —Stopping his cultivator, a grandpa admonished me
> The grandpa must have been the ancient old Ainu
> > Who in my dream last night mimicked the figure of a crane whose tail, the
> > > way he walks, is beautiful

The poem has a line: "The ancient old Ainu's crane whose way of walking is beautiful"
 The Ainu are an ethnic group who originally populated much of the northern part of Japan. A recent investigation has shown that the Kennewick Man, found in Washington State and thought to be eight thousand years old, is closest to the Ainu.

Terrify!: refers to four lines earlier, but here used like a call of a crane: *quork!*

Be its pillow round—: Poem No.829, to which Emily gave the title "Country Burial," reads in its entirety:

> Ample make this Bed—
> Make this bed with Awe—
> In it wait till Judgment break
> Excellent and Fair.
>
> Be it's Mattress straight—
> Be it's Pillow round—
> Let no Sunrise' yellow noise
> Interrupt this Ground—

Thomas H. Johnson says: "There are four fair copies, identical in text but written in different years." In each of the three versions Johnson cites, "its" (as in Yoshimasu's citation) is given as "it's."

(*Soshite marude tampopo no sode ni yadotta*
 And made as He would eat me up—
(*Itteki no shizuku o nomihosu yō ni*
 As wholly as a Dew
(*Watashi o nomihosu kakkō o shita*
 Upon a Dandelion's Sleeve—
(*Sokode watashi wa aruki hajimeta*
 And then—I started—too
(*Suruto umi wa sugu ato o ottekite*
 And He—He followed—close behind—
(*Sono gin no kakato o*
 I felt His Silver Heel
(*Watashi no kurubushi ni kanjita*
 Upon my Ankle—Then my Shoes
(*Sorekara watashi no kutsu ga shinju de afureta*
 Would overflow with Pearl—
......

(*Umi wa hitori mo chijin ga inairashiku*
 No one He seems to know—
(*ōkina manazashi de watashi o ichibetsu shite*
 And bowing with—a Mighty look—
(*Shirizoite itta*
 At me—The sea withdrew—

 (*Toshikazu Niikura-san, from the same book, p. 23*)

And bowing (again it's B), So the sea too bowing withdraws, its body, as it goes
 away
How's that

Scent of Ishikari (Inkari no ka), although I am a B-class poet, I've *begun* to learn
 "And bowing...."
At a place called *Chambre* in Sapporo Station (within its building), waiting for
 the connection (P.M.3.00~3.30),
though I wanted to drink dark/lager beer, "someone has taken this mountain
 path" (*Shinobu Orikuchi-san's tanka*)

"Being inside the building was for some reason *terrifying*,"
I prick up my ears to, *at*, the footfall of an ancient old Ainu's crane. My ears
 next to,

(Angels rent a house next to us / no matter where we move
Terrify! Crane's bed,—

(*Massuguni seyo, mattoresu o*
 Be its Mattress straight—
(*Manmaruku seyo, sono nakura o*
 Be its pillow round—
At the entrance to the two B's lying side by side, clouds, slowly, collapsed/
 broke

"C!"
"C?"

———

: TRANSLATED BY HIROAKI SATO

Translator's Notes

This polyvocal text was created in the process of multiple levels of revision, as Yoshimasu went back to a first draft, added new alternative phrases, using slashes, commas, and quotations gathered from around him. The result is a complicated, multi-layered text that evokes multiple scenes at once—a trip to Scotland, a trip to Frank Lloyd Wright's studio in Wisconsin, as well as a scene in the Musashino Plains of Tokyo.

Japanese tends to use very few pronouns, especially in poetry. This text is no exception, using only an occasional "we" or an "I"; therefore, it is often ambiguous who is doing the action in any particular moment. In the Japanese, this ambiguity is not much of an issue, especially since we understand there are, in a sense, multiple "Yoshimasus" in this poem, each of whom is describing a particular scene. English, however, forces us to have a subject in each sentence. As a result, I have usually chosen, whenever there is some ambiguity, to use the pluralizing "we," in order to emphasize the multiplicity of voices in the text.

The quote from Macbeth comes from the famous Act 5, Scene 5, in which a messenger announces that the woods seem to be moving, thus letting the audience know Lady Macbeth's prophecy is coming true. In the Japanese, Yoshimasu includes the original English (here in italics), along with a Japanese translation by Sawamura Torajirō (1885-1945).

To the House of Deaf Mutes

———

(Wanna go outside and dance?
(Sure, but you know.

 Quietly, the shore, asked, the river goddess, in a whisper. (Lovely,).
 The tree roots, under the tree, (.), on a day, that seems as if it has
learned to walk, two, three steps, down the corridor. We could see a
single ant in the green leaves, listening to the echoes, resting, in the shadow
of a small stone.

 Hills with all the time of billions of light years, shone, along with the
shade of trees.

 We heard the sound of paper tearing. Would we hear a "deep voice"?
"I/the author" did not know. In the dream, the position of the "creek of
dreams/milky way" we would cross, was pleasant, like passing second base.
Where from? "I've walked along the surface of a wall." Our fingers, hand-
in-hand, smell of a rented car.

(The scent of a tree of learning that is completely wrong?
(That's right. The scent of a tree, that is completely wrong.

 Quietly, (crawl, it's okay, to crawl).
The rain, does it bring sound? On the hem, does it "rub (grate at?)/"
"slide/slip"? "bite/gnaw"? We stopped, thought long and hard on the shape
of the leaves on the branches, and started writing. "Squirrel/I".

Little, by little, little by little. The bud (bloom) of the fruit on the tree on the
shore of the universe's, "muscle/sinew"'s "picture?", reflected in someone's
heart. Little, by little, little by little. The children start sliding. A basket's,
"roots/skirt."

On the shore of the unknown, snakes and vines intertwined, giving rise to the universe.

That, "Gare/is it the station?". "I don't know."

We began to hear a mysterious echo. "Kusuko is dead."
A ray of light penetrates. "Nameless/ball" came, "was standing/was me."

Language is, usually, "in the imperative form/quiet/stone's/eyes/quiet."

"The beautiful/suffering/that sprouts up."

"House of deaf-mutes"

JFK Airport/TWA 769. Hydraulics in the feed/oil leak. Man, we were stopped for a whole two hours. Days like this are lovely. One moment at a time. Evening (the dim light of dawn) descended, over us, the body of a snake, diagonally, straight, two or three. It begins to rise (it lifts itself) into the sky.

Hirata Kaori-san. What do you say? Vi, et, nam's, morning river's, heart thumping (quiver) beat.

That's right, even so, the riverbed has never been washed away, not even once. "A life so embarrassing that one thinks about it," is, "above," isn't it?

The dirty head, dirty head, dirty head, of a large bus,......

It is a spring evening somewhere. I will stand right here,......

(Even if you fail in life, there are some pleasures.)

The spring dew is "on the surface of the lake/α, υ, isn't it? Interestingly/ busily/finishes/shades/the shadows from the leaves/lowly/one leaf/two leaves/ with/take (capture)/collect/was/the squirrel house in the Japanese evergreen oak." As if to say, that was not my house, that is not my tail, the universe, or a turtle's back smashed and set flying in an instant/is not a garden where a whooper swan stood. Maybe there was one there.

We were imagining a boat packed with "people/letters/gifts."

Did the small Mazda reach the hill in Ranhō?/ We were worried and tried calling, but we didn't know how to use the card-operated telephone at the airport and ended up listening to the code recorded by the operators for a while. What is this? "Crossbreeding (mating) with grey/it is a forest of voices."

Just a little to the left and behind the chlorite quartz, there were magnolia flowers.

"Hill of voices/forest of voices," "a place that exists nowhere,......(leaves)" We walked like the wind blows.

That

"Gare/station."

"Edinburgh."

Hill of voices/came standing upright /we were.

"There/entrance," "spring/stuffed animals" (......als?) huh, what was that again?......

(We came standing up,
 old,
 time too,
 the milky way's
 depths too,
 came standing up
 and danced on the window ledge,
 (are dancing),
 we pay a visit to
the white magnolia tree.

(Where did you come from?
"Keio University/the publicity relations office.")

We "put in/sent" a "white magnolia/white envelope." The station building, (oh, I see,......), a "spot behind/place" where "small horses/ places behind/forms" gathered. Huh?, "I'll, gather them, in the house of the deaf-mutes."

The "heart/things/and/sending my manuscripts" in the station. "Do the roots grow thin/ grow old?"

("Yeah/yeah."

"When their roots grow thin/grow old." We carry a "porcelain panel/ sunny spot" into the garden of the spring palace, and "I/the snake" "lean my body forward/listen to the sound of footsteps." In such a place, that thing they call "the autumn of old age" is nice, we took Buson. What's that all about?

? Heavy.

I am, a spider (, look up!)

"The sound of a cock crowing."

This station's foot-high fence, "beside it,

The house of deaf-mutes,

To it......" White/tree/lotus (tree+lotus=magnolia).

(I was trying to draw the flowers.

—Here in this place, on this little hill, Wright came up with the name Taliesin.

Taliesin is Welsh for "shining brow."

The Welsh word ‹shining brow›'s "shady (illuminated) hill/lovely/soft/ illuminated/shady/hill/hillock."

We passed through, from the backside, the quiver? the sky? the brightly illuminated sunny road with a sheepskin pulled far over its head

"Shady hill," that trembles.

Suddenly,

 frightened,

 into a bow,

 the snake

 is,

 white,

 and hides,

 itself,

 in the shade,

 of a rock,

 no sooner did we realize,

 than the fence

 had stopped

 the planets

still,

so,

 they did,

 not move.

 (Lean, a little,

 a little,

 more, lean in,

 somewhere,

 a lovely,

 wick,

 foot-long,

 beside it,

 a mysterious,

 cheek,

touched,

touched,

 soft,

 shady hill,

 "the shady hill……").

It was a thistle (*azami*). We dissolved the English word thistle/thistle (*azami*) over, and over, again, in, our, mouths.

(Who was this, picture, postcard, addressed, to?

"I guess it must be" morning. We stood up "a single picture postcard" so the window would strike it, and we slept when we heard a ghostly voice come to us.

(*shi, su, ru, mi, shi, I, shi, su, ru, shi, su*

We didn't understand.

(Pencil sharpened, will the paper return? "*suru*"=to do? "*shisuru*"=to die/pass away?

As it passed through (become transparent......), the landscape moved. Saying *shisuru, shuru*, we could not see it, but (the hands/fingers of) the creek, stitched the forest. The gasses and mist, cleared, the foot-wide....Thank you. Lizzie (You say that means Elizabeth?) author (Shakespeare) has certainly, not been here either. It approached the edge (side) of the Birnam Woods. How embarrassing. But, at that moment, it formed a golden boundary.

"It's laudable,...... " The universe too.

As I did stand my watch upon the hill I look'd toward Birnam, and upon, methought
The wood <u>began to move</u>.
 (Shakespeare, *Macbeth*)

Sure, what began to move, was the old landscape (a foot's worth of landscape,......) I could see it clearly. The rivers in the fields of Musashino, the hollows, grown old, there, crystal/emerald/dust made to fall. *and upon,* <u>*me*</u>*thought*, a moment later, it began to move, without a doubt.

and upon, <u>*me*</u>*thought/oh, yeah, it began/had begun to move.*

Quietly, the growth, at the corner/side, white/*kensaku*. "Young/meterorite"/"beginning/nest/complete" a form/shape I try/to/imagine/but can't,......"'s/universe/corner"

"to know/dream,...... "
The gentle oars of night.

Dyed "'s/color"/ "the gentle/oars of night."

"Dyed/in/gentle/oars/night"

!

"That's where it brushed across my cheek"

The echo of the milky way in the god-window of the house of deaf-mutes. For some time.

It retreated, into the distance. A small whirlpool. The nameless snake entangled with the universe and stood up.

Lean, a little

As much as you have retreated

The echo of the milky way in the god-window of the house of deaf-mutes. For some time.

(The stars weigh heavy

"The words of the river goddess,......"

"Oars/of evening"

's

we listen to the "growth" of the voice (hill,)

"It's quiet"

(Yeah, it seems to have started moving
(Yeah, it seems to have started moving

———

: TRANSLATED BY JEFFREY ANGLES

Translator's Notes

———

The setting for this poem is an archaeological site in northern Japan that the poet visited, where lacquer implements were produced during the Jōmon period (14,000–300 BC). The "love tree" is what Yoshimasu calls the lacquer tree, whose sap is used to make the lacquer finish. The poet explained to me that the attempt to embrace the tree is not only because the tree has never embraced its own mother, but because the poet himself bears the traumatic memory of his mother's refusal to openly show affection. The kiss of the lacquer tree is also the sensation of the lips touching the rim of the lacquer soup bowl while eating, and the tree's open wound is the opening of the bowl. Deep red is the color of lacquer, but Yoshimasu also has in mind the color red in the paintings of Paul Klee. Yoshimasu was reading the diaries of Paul Klee at the time he wrote this poem, and images of Klee's paintings are an important element in all of the poems in the collection to which this belongs (*Naked Writing*). The goddess of the grottos represents the women of ancient times who made the lacquer implements. (Perhaps the goddess also represents Yoshimasu's own mother?) I have kept characters used in the original as markers for reading and performance with their possible translations or interpretations appearing after in italics.

Here text itself becomes the site of performance. Notations for reading and the embodiment of performance in the form of graphic image and symbolic elements ultimately are reduceable to themselves (i.e., are not "translatable"). The poem overflows its own boundaries into performative ritual and other genres such as film, in which the poet translates his multilayered poetic montage into one of visual image and sound. (There is in fact a film version of this poem.) The poem here reaches back into prehistory where Yoshimasu attempts to "reinvent" Japanese in its classical form, the Man'yogana, in which Chinese characters were used purely for their phonetic values. The character "尾" ("o") is used here to denote the direct object particle instead of the modern を. I have kept those characters that act as markers or signs in the translation, and have generally attempted to reproduce the graphic effects of the poem. Due to its visual nature, part of me would prefer to keep the poem in its original and simply add critical commentary. Either this or an interlinear translation in which word-for-word translations are provided below the original lines.

The Love Tree

———

Squirrels whistle from above, faaaaar away, holding one hand up high
Deep in the Aizu mountains, August 2010
I tried to kiss
The open wound of a la————cquer (漆…) tree

Squirrels whistle from above, faaaaar away, holding one hand up high
Because [it is] a body never before embraced [its] mother HAHA (�ण…) 尾 [wo]
("Karada dakarada – Because [it is] a body,)

Lacq ("濡ル," wet カ or is it) ツ, uer ("黙レ," silence "嗼ム," mouth shut カ or not)
The heart is emBRACED by the forest ("芯," the core カ), griffe (of birds and beasts,)
= claw (gum,)
I don't know what to do,

Lacq ("濡ル," wet カ or is it), uer ("黙レ," silence "嗼ム, " mouth shut カ or not)
August 28, 2010
Deep Red! Beyond the glass doors of the prefectural museum, the "pale palette" of Jōmon,
The Goddess of the grottos begins to sing, ——————————

Squirrels whistle from above, faaaaar away, holding one hand up high
La———— cquer, lacq
Uer ——————, mouth (チ ,…CHI/blood/knowledge) of the love tree

———

: TRANSLATED BY ERIC SELLAND

IV.

Translator's Notes

―――――

The title of "Firecracker House" was inspired by the Edgar Allan Poe story, "The Fall of the House of Usher." After a long immersion in the tastes, smells, sounds, and, of course, the language of Brazil, Gozo may have been in a state of sensory overload like the character in the Poe story. It was this state of poetic hyperesthesia perhaps that amplified the news that shocked Japan: the serial killing, cannibalization, and necrophilia of young girls in western Tokyo (see "the Otaku Murderer"). The horror took place near Ome along the Akikawa River, where Gozo had hunted fossils as a boy. He later discussed how his memories merged with the sensory stimuli of the present and his feelings about the news. It wasn't until over fifteen years after "Firecracker House" first appeared in print that he was able to—or rather *had* to—talk about its genesis and the creative process.

薄いヴェールの丘にたち、静かに "病い" を待っている
Standing on the thin veil of dunes, quietly awaiting our "illness."

Our illness? The illness? Just illness? I have gone with "our illness". The overall voice of this work seems first person plural (alone and together at the same time).

宇宙船には繻子の靴がない
The spaceship has no satin shoes.

繻子の靴
shusu (satin) no kutsu, a play on words with the English "shoes," shoes, *no kutsu*, shoes of shoes.

お嬢さん
o-jou-san is a young lady, Miss, girl, … or perhaps mademoiselle.

月の桂
Katsura, tree of the moon. Chinese legend had it that *katsura* trees (judas trees) grew on the moon.

At the Entrance to the Firecracker House

———

Standing on the thin veil of dunes, quietly awaiting our "illness"
 —The words of Gelson
"The unicorn buried its face in the leaves, thinking:
 the spaceship has no satin shoes"
USP (Universidade de São Paulo), standing at the main gate:
 —Young lady. *Katsura tree* of the moon, ... House of the leather
tanner's song

(Are you, ...) a beautiful (green plum) hollow tree?

Ash-colored spirit of the *katsura* tree stood and spoke to us on our own narrow
road to the interior

 Falling on the garden (of the children) of Azulados Ovos (pale-blue eggs)
 — I,
 frost, ... *shimo*, ... Shimo, ...

 Toho, ... , harvest time,
 "Village Spirit", Akikawa,

Firewood (of the people of the cardboard houses) stacked beneath the cherry tree
 (Our rough sketch of a beautiful garden)
Drawing a bow across the strings of a chipped violin, without making a sound

Finally: Zoon, giant spots on the snow dice soaked into the "picture" on
"our *tenugui*"
Green and gold blades of grass to the lower right of the goal posts, Venus
appears in the sky
with Saturn and Jupiter, we walk toward the place we named "deep mind"

青梅

Ao-ume: green plum, "Japanese apricot"; the same characters are used for Ome, a city in western Tokyo Metropolis.

わたしたち (our) の奥の細道

Narrow road to the interior refers to the travel diary of the late 17th-century Japanese poet Matsuo Basho.

蒼ざめた卵

Azulados Ovos (Portuguese): pale blue eggs.

frost, ... *shimo*, ... Shimo, ...

A play on words and kanji: 霜 (*shimo*: frost), 志茂 (Shimo: place name).

吐穂の季節

Toho, ... , harvest time, ...

Toho 吐穂 is a manufactured word combining two incongruous characters: 吐 "vomit, expel" and 穂 "head of grain." It is intended to express a feeling of surreal disbelief, but I translated it simply as "harvest."

秋川

Akikawa: place name, both a river and town in western Tokyo near Ome.

泥(ズ)ン

Zoon, the character, means mud, mired in mud, used here phonetically: *zun, zoom, zloom*

手拭

Tenugui is a thin Japanese hand towel, usually with a graphic decoration; I refrain from calling it a bandana.

心の奥

"deep mind": within my heart, my mind; inner heart, inner mind (on our way to the deep mind of a sublime poetic imagination).

東洋者街

Liberdade (a district in São Paulo, Brazil, home to the largest Japanese community outside of Japan). The entrance to the town is marked by a large red *torii* gate.

Lovely garden /, chicken feet
Under a mound of dead whales (holding a candle)
Pinocchio hangs his head
I can no longer see the *torii* gate deep within my eyes
 Standing in the market on Friday: (the children) of Azulados Ovos
 Stroking the back (of my, . . . hand), fireflies floating sideways

Silence,

Standing on the thin veil of dunes, quietly awaiting our "illness"
 —The words of Gelson
"The unicorn buried its face in the leaves, thinking:
 the spaceship has no satin shoes"
USP (Universidade de Saõ Paulo), standing at the main gate:
 —Young lady. *Katsura* tree of the moon, . . . House of the leather
 tanner's song

Crouching down, . . . (whose land is this?)
At the crook in the neck bone, the smell of a meteorite
Fruit and a fine knife, light of an orange sun

(Nécropole—necropolis) of violet flowers, beneath the flowers
Guests arrive

What I try, to do in a poetry collection
is
I try to jump

Summer day, (not braying for now, . . .) my throat a bit hoarse
"Image of a hilly road" came to my dream and whispered, to the image of my
dearest cave
"A bit hoarse, . . . / but let's *do* it" was "my own voice"

Young horse and cart, heading down, go/stop, twisting to a stop
"Waiting, for you" quietly asking the name of the road
 (My first friend in this land)
 Avenida Rebouças, Bridal Avenue
 Green paving stone, golden rain of the U of the horseshoe

夢の奥
"deep within my dream."

emi: えみ, smile; 笑み, fine crack; 小亀裂, small turtle.

阿羅わ
Ah Ra Wa (the "cycle" of an *arhat*).

さくら
Sakura: cherry tree; also means a swindler, decoy, or customer generating an artificial demand for a vendor.

杏林大学
Kyorin University, a school in western Tokyo that began as a sanitarium for tuberculosis patients.

胡歌
The Northern Barbarians: the term refers to nomadic peoples from the north of China.

I was first struck by the quietness and complexity of the opening scene. I was next struck by the completeness and coherence of Gozo's poetic vision as it evolved over the years. It was perhaps more obvious because I had just finished re-reading and translating some of his earlier works, including his 1970 masterpiece, "The Ancient Astronomical Observatory." The opening lines of this work are representative of the youthful power, like the improvisational jazz that accompanied the dramatic, smoky poetry readings of those days:

> The world began with a sparkling murder!
> This morning
> in the snow
> screaming:
> "A star is the key! A star is the key!"
> Dreaming:
> murder.
> Thinking:
> murder.
> Singing:

Evening, "graceful garden" / chicken feet of Liberdade (Oriental Town), were
they sleeping?
 Lunar halo, luminous white—(peering into my binoculars, . . .)

I was "washing clean," amazingly clean, what could have happened? (This
evening, not at all dirty with mud.)
Young lady, hung up on the fence like laundry, like a U, like a ∩
 (Like a U, like a ∩)

"I build
 a maze"
In the back of my hand, floats the small face of a skull
(Won't you come with me? . . .)

"Because the moon is the shoe of the universe,
 take your pillow of air and go," when I slept, the voice came from within
 my dream
. . . (half way to the sky, . . .), *emi*:
 ("smile" and "fine crack")
 " e/mi"
(small turtle at the doorway/pail of water)

Nearby
 A bonfire
 "graceful garden/chicken feet"

The house of air is—a little like Ah Ra Wa (the "cycle" of an arhat)—the green
trees that line the night road are like gold coins
 (Echo-ing, . . .)

Corinthians

Ash/colored

 Falling on the garden (of the children) of Azulados Oros (pale-blue eggs)
 —I,
 frost, . . . *shimo*, . . . Shimo, . . .

"Yesterday was black hair chandelier.
Yesterday was black hair chandelier."

Yoshimasu Gozo is never standing still, either physically or artistically, so it should come as no surprise that his style in the 1990s would be a long journey from that of the 1970s (just as his more recent works in this volume show continued evolution). I cannot help but be inspired by how each phase builds on and complements what came before, and how the poet as wanderer is manifested in an amazing body of life work.

Toho,..., harvest time,...
"Village Spirit", Akikawa,...

Toward the interior, turn, and disappear

—Shade of a (cherry...) tree, of the roadside vendors

"We genitals
 are eyes,
 that's why"

 I also wanted to be (one of those children)

At the entrance to the firecracker house, a sick silkworm
 "Shine of the lapiz lazuli" dancing

 Falling on the garden (of the children) of Azulados Ovos (pale-blue eggs)

At the entrance to the firecracker house, a sick silkworm
 When it entered the "cocoon" it was an "ash colored horse"

Falling on the garden (of the children) of Azulados Ovos (pale-blue eggs)

At the entrance to the firecracker house, a sick silkworm
 It may have been in the shadow of spices in a corner of the marketplace
 (*souq*) in Damascus

And then, sliding doors with *shoji*, old newspaper

Falling on the garden (of the children) of Azulados Ovos (pale-blue eggs)

A crying voice below the "pure water" of the "mountain god"

At the entrance to the firecracker house, a sick silkworm
 On the dunes far away from "Akikawa"

 Falling on the garden (of the children) of Azulados Oros (pale-blue eggs)

Coming this far, we started making a white gate

The "white Corolla" covered up at Kyorin University

Falling on the garden (of the children) of Azulados Oros (pale-blue eggs)

The shine changed from the color of lapis lazuli to peach-green

At the entrance to the firecracker house, a sick silkworm
Discarded, walking toward the white gate

Holding white egg stones, knees slightly bent

Mysterious form

Walking away

At the entrance to the firecracker house, a sick silkworm,
Dead star (singing the song of the Northern Barbarians, . . .), under the tree, spirit under the green moss

Songs of the northern barbarians, To Ho and Ho To, . . . (Mother, I wanted to get lost in every nook and cranny of your body)

What happened to the Kropokkuru and their "smiles"

(next to the bonfire and chestnuts, the beautiful echo of the chestnuts,

upside down in places,

Snake of the picture (on the blond dune, . . .) (sexual intercourse, slowly, . . .)

At the entrance to the firecracker house, a sick silkworm,
Discarded, walking toward the white gate

Holding white egg stones, knees slightly bent

Mysterious form

Walking away

At the entrance to the firecracker house, a sick silkworm
(Rocked in a magnolia boat,

Falling on the garden (of the children) of Azulados Ovos (pale-blue eggs)

Empty shell, Karak-ko, … (spring silkworm), Kazuro

Sunlight through the trees, beyond the threshold

Image of, looks like the Shinkansen, … Looks like

"The tree is the lingering boat," on the back side, it's fine to turn to just that
point
The grove of stars, the pod of a magazine

of "looks, like"

of "looks, like" the precincts of the shrine to the goddess, … "looks", "like"

(The magnolia boat departs
Becoming little people, becoming Kropokkuru
The wood grain rocks)

(Hammock
Boarding the magnolia boat
The gate rocks)

With its face buried in the leaves, the unicorn is thinking. On the back
mountain, round moon, behind the moon's U (∩), more cosmos. Softly
(kindly), folding her arms, mother. Shaggy, foundation, its face buried in the
leaves, the unicorn, rustling paper made mysterious sounds, looking up,
murmured. Floating in the swamp, the cosmos

Wa

I think the spirit of Brazil's mountain cherry (Jacaranda) was extremely
embarrassed
 (The tree bark was like sweet flames; the ant parted from the insect with
 downcast eyes)

It is easy for me, to see, for I am from a foreign land. Trying to hide it
 Clouds (Hey, felled tree!) of the "evening shower and grey"
 descend, lightning flashes!

As the drenched moon rose on the ancient lake, the moon: "How
 can I hold on to this memory, ... ?"
"We are bright"—and (...,) there is nothing on
 the wick

U

Entrance to the firecracker house

Standing on the thin veil of dunes, quietly awaiting our "illness"
 —The words of Gelson
"The unicorn buried its face in the leaves, thinking:
 the spaceship has no satin shoes"
USP (Universidade de Sao Paolo), standing at the main gate:
 —Young lady. Katsura (jude tree) of the moon, ... House of the leather
tanner's song
Quietly, standing, are you, a beautiful (green plum...)
 ... hollow tree?

———

: TRANSLATED BY RICHARD ARNO

Translator's Notes

———

More than anyone else I know, Gozo lives on the road. He is constantly on the move in search of visions. He strains his eyes, he strains his ears. He finds traces of our shared mythology in the everyday and the extraordinary. He is naturally drawn to the edges, to the islands and fissures, the cracks and pressure points of the planet. Places where one environment encroaches on another, where one language kills off another, where dead and near-dead languages live on in the place names and words whose meanings have been forgotten. Places like Hokkaido, Okinawa, the high desert of New Mexico…

My first encounter with the poet was during one of his sojourns, this one to the American Midwest where he performed one of his powerful poetry readings at Oakland University in the late seventies; it must have been early spring, since I recall the grass showing through the footprints in the snow. (I wonder if he ever wrote about my old junker with the bashed-in windshield.)

Gozo's output takes many forms: poetry, of course, as well as travel sketches and essays, photography, visual arts in various media, and, more recently, video (a newer outlet, which Gozo calls *gozoCiné*)—all different ways of modeling the consciousness of experience. For some of his travel-inspired essays in English, see *A Thousand Steps … and More: Selected Poems and Prose 1964–1984* (Katydid Books, Oakland University, 1987), which includes a number of (my) translations from *Shizuka-na Basho* (Silent Places, 1981).

I have always known Gozo to have a study, overflowing with the most amazing and incredible books from around the world. But sitting at his desk and writing poetry? It strains the imagination. No, rather it is when walking the streets (is that a red lantern?), taking a train, boarding a ferry for the outer islands, that creation takes place. (I'll drop you off at Windsor Station; shall we take the tunnel or the bridge?)

In a series of interviews published recently in the *Asahi* newspaper, Gozo described the creative process that has driven his work over the years. He seeks inspiration by placing himself outside of the day-to-day, by stepping out into the world. Especially in foreign countries "language will splinter and dry up" and creativity can only begin when "the spring is completely dry."

This made me think of the prose poem "Lamy Station." Several decades before making that remark to a journalist, he had made the perfect escape from the tyranny of language. Standing in the twilight at Lamy Station: the poet as an empty vessel, an artesian well, channeling pure water from the source.

At the edge of the desert lies a sparkling sea.

Lamy Station
Santa Fe Railroad Lamy Station

———

Twilight, a deserted station, the Sante Fe Railroad, we stood at Lamy Station. There was a thicket of bushes and an old Cheyenne, sitting. (Or he wasn't there at all. My memory has a thicket of bushes, an old Cheyenne, sitting.) —When, I heard, it, a clear day in autumn, twilight, a deserted station, the Santa Fe Railroad, we stood at Lamy Station. The Rio Grande, a deep crevice, long ago, the Indian children played, chasing squirrels and weasels. On snowy days, the Rio Grande, makes the crevice deeper. A clear autumn day, there's a clock in the station, (I don't know) the schedule, the Santa Fe Railroad, we stood at Lamy Station. Across the Rio Grande, a white building, a mad house stands, across the Rio Grande, a deep crevice. A thicket, (beside) the bushes, we sat down, doing simple calisthenics: one, two, three, right? This world, is a giant, hospital. Hey boy with the long shadow, a walnut cave, hey chipmunk from Yatsugatake, hey squirrel, you pulled me along, we've circled the sun once already. I raced the gears (or was it an automatic?). That day, an autumn day, twilight, a deserted station, the Santa Fe Railroad, we stood at Lamy Station.

There was a thicket of bushes, an old Cheyenne, sitting. (Or he wasn't there at all. My memory has a thicket of bushes, an old Cheyenne, sitting.) In drunken exile, from an adobe house, from the reservation. (Or he wasn't there at all. My memory has a thicket of bushes, an old Cheyenne, sitting.) We are living fossils, hey chipmunk from Yatsugatake, hey squirrel, the Sioux, the Hopi. The chipmunk chewed, a splendid nest. Mud house, covered in mud, mad house, dressed in white (there are colored robes, too.) We, are, living fossils, yes, man is mortal. We, are, post-war, in the crevice, of, mortality. Any vacancies? To Taos/Pueblo, (getting out of our car) on a trail, walking, thinking (the tape won't go around, this trail, on snowy days). Thinking. Walking on a trail, that, winds around like a pitcher's form, do you know what I mean? We walked.

The Rio Grande, a deep crevice, long ago. The Indian children played, chasing squirrels and weasels. Some day, we may become, people, (getting out of our cars) living like Eskimos, in igloos, walking. At last, in exile. (Left for dead, on the side of the road,

line an, American car, with the license plates still on. Do you know what I mean?)
And then the Rio Grande, a deep crevice. The Rio Grande is a living fossil. —

 It flew over from / the Yucatan / Peninsula
 / a Congolese Macaw / holding up / a giant
 / feather / step / step / step
 / Macaw / Macaw / white
 / is / knowledge / black
 / is / chaos / green
 / is / the trees / of flora / red
 / is / the blood / of / man and beasts
 / Macaw / Macaw / Macaw / Macaw
Macaws and parrots, be, come, speakers of, human words (sacred tongues).
 In self-defense, they hold up, the giant
Feather, step (a beautiful side step) step, step,
 Hey Macaw, Macaw
 Hey Parrot, Parrot
One language may kill off another. We, are, living fossils. In step, rhythm, step,
step, sometimes, a language will kill off another. We, begin, our migration, to
another family of words. We are, fossils, of words. The sun comes shining down,
hey you people, walking in Nakano, near the Tetsugaku-do. (Or rather, hey you
chipmunks, hey you squirrels, hopping across the surface, of the planet.)
 Macaw, Macaw
With eyes, slightly blackened, hey you people from the Jomon period, near an
Indian reservation, looking down from the high hills, a single family, waving,
lonely. (Do you know what I mean?) In a coma, a woman, as though from the pages
of Penthouse, do you know what I mean? —We are, sad, with our not-so-clean
Chrysler, painted white, (even if it were a new car), could we be facing, the end, of
our planet? Of course, with the macaws and parrots (when the time comes, Exxon
Corporation, will you save us please? —You came down, from a mountain top,
in Santa Fe, San Ildefonso village, we watched, a harvest prayer, a harvest dance,
feeling sad. Even we, don't know, why. —Sadness is contagious, like a whisper,
that's why. "Standard Chevron, are you watching the dance?"
 Macaw, Macaw-aw
Indian dolls, will, you, save us, please? At last, twilight approaches, the sun, slowly,
sinks. That, earth, step, rhythm, one foot, plant, the roots, are thrown all over, the
setting sun, sinks, watching, the sky roots, we drive, to Lamy Station, on the Santa
Fe Railroad.

Yes,
twilight, a deserted station, the Santa Fe Railroad, we stood at Lamy Station.
There was a thicket of bushes and an old Cheyenne, sitting. (Or he wasn't there
at all. My memory has a thicket of bushes, an old Cheyenne, sitting.) —When, I
heard, it, a clear autumn day, twilight, a deserted station, the Santa Fe Railroad,
we stood at Lamy Station. Even if we retire, the bolts that hold the rails, are old, or
if we're drunk, we can only drive straight, (do you know what I mean?) At last, the
crossings, are all gone. On TV, the stories, of over-aged train engineers, the union
got a bad deal.

Finally, twilight,
approaches, the old Cheyenne, stands up—(He said, he doesn't know how, to
call the rain, to use a shaman's art) but pointing, looking from the back of his
eyes, several seconds, he stood up. The Rio Grande, a deep crevice, long ago, the
Indian children played, chasing the squirrels and weasels. On snowy days, the Rio
Grande, makes the crevice deeper. A clear autumn day—
 We also stand up.
Doing simple calisthenics. Where shall we go? Reading palms, straining our ears,
we don't know, holding hands, more calisthenics (when we get back, let's wash
the car…), thinking, alone, that's what it was. Hey chipmunk, hey squirrel, still,
chewing and chewing and chewing on your walnuts? Hey boys, hey girls, there's
already snow in the mountains.

———

: TRANSLATED BY RICHARD ARNO

V.

SHITA NO SHIGUSA / シタの仕草 /
a gesture of the tongue / an act beneath

———

Pūhā, pū, hā
breath of dawn, where dawn
is bled, the black of it, s-
igh under, its breath a part-
ing

"Pūhā ka honu ua awakea." Trans. "When the turtle comes up to breathe, it is daylight" (p.298 No. 2717. ʻŌlelo Noʻeau: Hawaiian Proverbs and Poetical Sayings. Mary Kawena Pukui. Bishop Museum Press.) Pūhā, Pū, hā, a turtle's expulsion of breath, more generally a bursting and, in the wake of the primary definition, a hollow. The hollowness of the mouth when the word has gone out.

a-, troph-, a, trough, a-
-fin-, -troph-, af-, -fine
blue, trou-, -gh! The long nails
of the w-, -ind trail,
a-, fin, af- fine, blue
trou-, -gh-

The eye somehow pressed to the dome of the sky; the mouth blinking. A stroke, like scarred metal, momentarily igniting the scales.

Wē, lau, a, lelo, le, lo, -le, ka, lau
alelo, the blade of the tongue, baring
the tip of the tongue

Not so much a leaf but a tongue (舌, alelo) of lava extending from the floor of the gulch to the sea. Reciting it, I trip into 'lole', as in "O ke au i kahuli lole ka lani." Trans. "time when unfolded the heavens" / "At the time when emerged the Exalted One" / "At the time when the skies turned inside-out" (Prologue, line 2. Kumulipo.) Beyond that measured superimposition of meaning, what is it that conveys the flavor of lole's ambiguity? Something enacted rather than heard, like a gesture of the tongue? I slip into Nabokov's choreographed Lo. Lee. Ta.

Come up, come he-
mo, hemo the school, I wa-
i noʻu, I wai, no, ʻu!

"I wai noʻu" "Said to challenge another to a game or contest." (p.137, No. 1264. ʻŌlelo Noʻeau.) Reading interviews with Joseph Ah Choy and Albert Stanley. ". . . I can remember those words coming out of my mouth." (p. 123. An Oral History of the April 1, 1946 Tsunami at Laupāhoehoe, Hawaiʻi: A Case Study in the Educative Value of Constructing History from Memory and Narrative.) The distance between that which is recalled as said and those words which have left the mouth. "Pūhā hewa ka honu i ka lā makani." Trans. "A turtle's offensive breath breaking to a windy day." Breath palmed by the waves and lost among the wind's long sayings.

the motion of a wi-
re tongue, in advance
of breath, a wire's breadth,
a wai（タンスイ）a wi-（淡い）,
re's breadth rain pat-
terning beneath her,
of-, fer-, red, o, F(fer)-
red, who, -se eyes, whose
eye bleeds the satin
hem-, -o, the sea
drawn back, red lei
about her ankles, they
rise, SHI-（ター）

The camera, film loaded, falling from Marsue's hand. The delicate shutter, its eye, the black of it, pressing against countless images. So sheltered, I dream an exhibit of photographs developed from unexposed film, depictions of absence indistinguishable but not interchangeable.

DoroʻdoroʻDorothyʻaʻdorʻaʻdorʻawaʻawaʻshuʻwa （手話）
ʻshuʻwatsuʻkaʻiʻtsuʻkai （使い）ʻhoʻoʻhoʻoʻhoʻiʻkaʻiʻkaʻikaikanani!

"Kai ka nani!" Trans. "How lovely!" Songs sung beneath the glaring moon. Words grasped by the corner, sounding again in her memory drawn taut. And beyond the turning door, the sky turning inside out. "Kahuli lole ka lani" A birth? I know that I grasp only the corner.

hurling
thinning
foam（フォーム）

Articulating the word at its shoulder, the whole of it becoming a gesture as it fails its grasp. From the other side of that door, she sees, in the years that follow, the reciprocal motion in his arms, proffering the red flowers about which (he believes) the waters swell.

napo, na pō-
haku （白）ka, wa, hi-（可愛い）
ne, "the stone-
eating woman"

"Ka wahine 'ai pōhaku." (p. 177 No. 1641. ʻŌlelo Noʻeau.) (Refers to Pele, goddess of the volcano, Kīlauea. Thwarted by Poliʻahu atop Mauna Kea, she dove between the cliffs, into the sea, leaving the black tongue of Laupāhoehoe Point.) "She was all, the whole body was just bruised you know, with sand in her ears, the eyes, the mouth." (Frank DeCaire's description of his adopted sister, Janet, as presented in April Fool's . . . / The Laupāhoehoe Tragedy of 1946 / An Oral History. Laupāhoehoe High, Middle and Elementary School. Obun Hawaii, Inc.)

the words ha-
lf-spoken, words you ha-
lve, spoken into sand

I thought I might hear it in the wind over sand shaped by the motion of a tongue between phonemes. But what emerged from the sound were a series of hollows, slotting into the sesquialtera of her understanding against the singer's breath. Without meaning too, I began to see sand in place of breath.

Ma, mo, he, mo, he, ma, mo, go
out deep, where, weʻa （赤ク）, na pō-
haku!

ヒット、リットリッ、ノッ、ノ、ッこり、ノッコリ（残り）、シィ、タ、ッシ、ッタ、イッ（死体）、ツノッッコッリ、ッシィ、ツオ（汐）ノ、ッコッウ、ツイッシィ、コッイシ（小石=pōhaku）、ツノッコ（子）、ツイシッッズ、ツマモ、ツル。

the words you have, spoken (all that has been, said)

beneath the tide, the stones
set(tle), close(r)
"gorogoro"

At 10:17am, on May 21st 2012, I listened to the stone tongue as it spoke to the sea, imagining her
tongue as it stumbled through the names. "Hard a?" Placing one hand atop the stones, I feel the hum
of a name through bone.

ka, ino, a, ka, i, noa (the name,
in its stone trough, o,
laka, ola, ka, inoa, o, lana, i-
wi, where would lie
the bones of the name

"Ola ka inoa." Trans. "The name lives." "Ola na iwi." Trans. "The bones live." (p.272 Nos. 2484 & 2488.
ʻŌlelo Noʻeau.) The stones settle, sounding the bones of the name. Rising amidst the thrum, a turtle's
breath.

e hoʻo-
pōhaku （石塊） e noho
mālie, e hoʻopōhaku
e noho mālie

Slowly as a stone coming to rest. The rumble of small feet along the black camp road.

ごろごろ
シッター

ごろごろ
シタ

———

: TRANSLUCINATED BY AUSTON STEWART

Interview with Yoshimasu Gozo

Interview by Aki Onda

Yoshimasu Gozo's creative endeavors have spanned half a century since the publication of his first book of poetry, *Shuppatsu* (Departure), in 1964. During this time he has cultivated a singular art form without parallel in postwar Japanese poetry. Some of his work is so unorthodox that it defies the print medium and can be delivered only as performance. Yet, although he has at times been regarded as a maverick, his unending quest to elucidate the essence of poetry places him firmly within a time-honored tradition. Perhaps because he came of age creatively during the 1960s and 1970s, when the Japanese cultural landscape was in its golden age of multimedia experimentation, he has never hesitated to branch out into other media: since the late 1960s he has collaborated with visual artists and free-jazz musicians; in the late 1980s he began creating art objects featuring words engraved in copper plates; and recently he has produced photographs as well as a series of video works entitled *gozoCiné*. Today, at the age of seventy-four, his

Yoshimasu Gozo. *Untitled*, 2008. Published in 『表紙』 Omotegami (Shityosya) © 2014 the artist and Shityosya.

appetite for creative exploration shows no sign of abating. This interview was conducted at the Pink Pony café in Lower Manhattan on October 1, 2012, the day after Yoshimasu and the guitarist and turntablist Otomo Yoshihide wrapped up a performance tour of five North American cities.

ONDA: Yoshimasu-san, first of all I'd like to ask you about the cultural landscape of Japan in the 1960s and 1970s and about where you fit into it. You published your debut collection of poems, *Shuppatsu* (Departure), in 1964, right around the time you graduated from Keio University. What was going on in Japan in those days?

YOSHIMASU: The conflict over the Japan-U.S. Security Treaty was raging, and that cast a long shadow over my student years. Of course, the sixties were a time of Americanization in Japan, and there was wave after wave of cultural influence: in literature there were the Beats, and in music there were folk singers like Bob Dylan and Joan Baez, who were followed a bit later by the Beatles. When I think back on those days, when I was in college, the person who played the single greatest role in introducing the work of the Beats to Japanese audiences was Suwa Yu. He was a poet, a translator, and an all-around great guy, and he organized frequent readings of Allen Ginsberg's *Howl* and *Kaddish*. In Tokyo he launched a magazine called *Doin'*, which dealt with music, photography, and poetry—and others, including Shiraishi Kazuko, Okunari Tatsu, Kusamori Shinichi, Okada Takahiko, and Sawatari Hajime, got involved. Suwa Yu was championing this cutting-edge poetry from the United States, and his circle was at the forefront of the poetry avant-garde in Japan.

Along with the poetry came jazz by Sonny Rollins and John Coltrane. The early sixties were really a cultural explosion on all fronts. Then, of course, the visual arts were hugely important, and spearheading the avant-garde was Takiguchi Shuzo. He was a leading champion of Surrealism in Japan and a unique character of the sort you rarely saw there. Takiguchi was originally a protégé of Nishiwaki Junzaburo, but he was truly a free spirit and, at the same time, a diligent, sensitive, and profound thinker. The cadre surrounding him included Isozaki Arata, Arakawa Shusaku, Takemitsu Toru, Tono Yoshiaki, and O'oka Makoto. There was also Hijikata Tatsumi, the Butoh dancer and choreographer. There was Terayama Shuji. All these people formed a sort of galaxy

around Takiguchi Shuzo, and they were the movers and shakers who shaped Japanese culture during that era, at least from a visual-arts point of view.

The next generation was that of Akasegawa Genpei, Nakanishi Natsuyuki, and Takamatsu Jiro, who made up the Hi Red Center group. Then there were the photographers Takanashi Yutaka, Nakahira Takuma, Moriyama Daido, and Taki Koji, who established the magazine *Provoke* in 1970 and made a major mark on photography. All these people were loosely clustered in one great galaxy, and artistic movements in postwar Japan took place in that context. Ikebana artist Nakagawa Yukio and Butoh dancer Ohno Kazuo were right in the hub of this galaxy as well. The action unfolded in venues like Minami Gallery, Tokyo Gallery, and the Tsubaki Kindai Gallery in Shinjuku. Art and literature flourished and intersected in this environment.

ONDA: I see. And did the poet Suwa Yu, who introduced the Beat poets to Japan, have a place in this galaxy as well?

YOSHIMASU: No, I don't see him as part of that galaxy. He was off on his own, a maverick. His colleagues in the field of British and American literature looked at him askance, and, in fact, he had plenty of enemies. He walked a thorny path in life and came to an early end, but I absolutely think he should not be overlooked. He translated *Howl* and *Kaddish* and the poems of Gregory Corso as well, I believe. He lived in Nerima Ward in Tokyo, and the literary crowd used to refer to him sarcastically as the "beatnik of Nerima," but I think what he did was really important. He led the way in promoting the culture of poetry readings and "little magazines"—noncommercial literary magazines that publish work by emerging writers—a movement to which Shiraishi Kazuko belonged as well. This was real subterranean stuff, even deeper than the so-called underground.

ONDA: So, what kind of relationship did you have with Suwa Yu?

YOSHIMASU: Suwa-san read my *Shuppatsu* soon after I published it in 1964 and asked me to write something for the second issue of the literary magazine *Subterraneans*. I still treasure my copy of that magazine. Around that time an extremely intimate yet totally open, genre-bending mentality prevailed.

ONDA: And that mentality coincided with the other things going on at the time, whether it was the Beats or the anti-Security Treaty movement?

YOSHIMASU: I think it was right around that time that Kenneth Rexroth came to Japan. He was the man they called the "father of the Beats"—a big, rough-edged guy,

Left: Cover of *Subterraneans* (1962), edited and published by Suwa Yu. Center and right: Cover and back cover of *Doin'* (1963), edited and published by Suwa Yu.

a member of an earlier generation of poets. After Rexroth, younger poets like Ginsberg and Gary Snyder came to Nanzen-ji Temple in Kyoto. Kyoto was always a hot spot.

ONDA: So you got the chance to meet some of the American Beats?

YOSHIMASU: That's right. Also, Robert Rauschenberg came to Japan in 1964 and did a performance called *Twenty Questions to Bob Rauschenberg* at the Sogetsu Art Center, which led to the creation of his famous work *Gold Standard*. Around that time, some brilliant guys from the French literature department at the University of Tokyo, like Tono Yoshiaki and Iijima Koichi, had formed a group that studied Surrealism, and their breed of art criticism was beginning to be a dominant cultural force in Tokyo. All of them were stars in the Takiguchi Shuzo galaxy.

ONDA: Hmm, it's interesting that Takiguchi Shuzo himself originally specialized in French culture, but that later, American culture began making inroads into that galaxy of his.

YOSHIMASU: One of the big influences there was Marcel Duchamp, who fled France for New York, in a kind of self-imposed exile. The same is true of Max Ernst. We can't forget the fact that America's avant-garde had connections with France. Arakawa Shusaku made New York his base of operations as well. As French intellectuals migrated to New York, France ceased to be the global cultural epicenter. Even Claude Lévi-Strauss followed this same path. And the Japanese cultural landscape of the sixties, formed

around Takiguchi and the other followers of Surrealism, echoed this trend. Of course, this is mostly information I gleaned from magazines and hearsay, though I'm talking as if I experienced it firsthand. I try to avoid talking like that.

ONDA: So would you say that Japanese intellectuals were learning from the French, and as the French drifted over to New York, the Japanese followed that trend, discovering contemporary American culture and starting to import it into Japan?

YOSHIMASU: That about sums it up.

ONDA: What kind of place was the Sogetsu Art Center?

YOSHIMASU: In ikebana flower arranging, there are conservative schools like Ikenobo and Koryu, and I believe the Sogetsu school was an offshoot of Ikenobo. Teshigahara Sofu, an incomparable ikebana genius and the father of the film director Teshigahara Hiroshi, established the school. Out of the old soil of this tradition-bound world sprouted the most innovative of movements, and it revolved around the Sogetsu Art Center. The Teshigaharas were wealthy and had this fantastic venue, and it grew into a

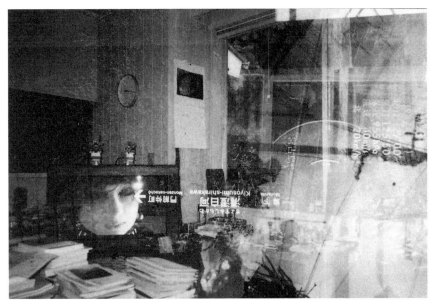

Yoshimasu Gozo. *Untitled*, 2008. Published in 『表紙』 Omotegami (Shityosya) © 2014 the artist and Shityosya.

kind of cultural ground zero. Meanwhile, in those days the *Yomiuri Shimbun* newspaper sponsored a big annual exhibition called the Yomiuri Independent. Kaido Hideo, the chief editor of the *Yomiuri*'s arts section, was the driving force behind the Independent, and a lot of talented artists made their debuts there. The exhibition had links with Sogetsu, and Takiguchi's circle had ties with both as well.

ONDA: It sounds like it was all connected, that there were no barriers in those days between the visual arts, literature, dance, and other fields.

YOSHIMASU: The lack of barriers back then was staggering, when you look at the way things are now. The arts were a "liberated area," to use a phrase in vogue around 1968. In terms of poetry, the early sixties Kyoku movement was revolutionary. It was spearheaded by Amazawa Taijiro, Suzuki Shiroyasu, and their associates. At the same time other movements were gradually emerging in political activism, popular music, popular entertainment districts, art criticism, Ankoku Butoh dance, the jazz scene, and the avant-garde theater of Terayama Shuji and Kara Juro. Terayama and Kara had ties with Takiguchi Shuzo through the dancer Hijikata. The thing about Takiguchi was, he was quiet and mild-mannered, but he always showed up in person when something

Yoshimasu Gozo. *Untitled*, 2008. Published in 『表紙』 Omotegami (Shityosya) © 2014 the artist and Shityosya.

was going on. No matter how small or insignificant an event, he was always there in a corner watching it. That's not something you can say about any old egghead critic.

Takiguchi's golden protégé was Takemitsu Toru. Most composers would name another composer as their primary mentor, but Takemitsu calls Takiguchi his greatest teacher. That gives you some idea of how wide-ranging Takiguchi's influence was. Others who cite him as a mentor are the artist Arakawa Shusaku and the architect Isozaki Arata. He was at the center of all this artistic activity, straddling all kinds of disciplines. He had a playful side, which he showed by doing things like making handmade passports and distributing them to young friends of his, and he was a defiant nonconformist as well.

ONDA: That must be why he was able to forge bonds with people from such different fields. What kind of work did Takiguchi himself do?

YOSHIMASU: His best-known piece of writing is Kindai Geijutsu (Modern Art), but he was also known as a Surrealist and was recognized for his presence alone, his originality and primordial energy. Yet although his associates viewed him as a legendary art critic, in the academic world and among those outside his circle, he was undoubtedly seen as a dubious character. Late in life, he became obsessed with producing works using the technique of decalcomania.

ONDA: What kinds of connections were there between Takiguchi's circle and the Sogetsu Art Center?

YOSHIMASU: I wasn't terribly close to that circle and so I couldn't tell you exactly, but there was a journal called SAC, which was a kind of all-around arts magazine. They paid the writers very well, since the Sogetsu organization had plenty of money. Various critics under Takiguchi's influence, like O'oka Makoto, Tono Yoshiaki, and Nakahara Yusuke, wrote for the magazine. On the film side of things, there was an odd magazine called Eiga Geijutsu (Cinema Art), which revolved around the late Ogawa Toru. Some of its writers were Yoshimoto Takaaki, Mishima Yukio, O'oka Makoto, and Iijima Koichi. All of these magazines—SAC and Eiga Geijutsu, as well as Kikan Film (Film Quarterly) and Bijutsu Techo (Art Notebook)—were very open-ended and broad-minded. As for literature, the journal Eureka hadn't come out yet; I suppose the big one was Gendaishi Techo (Modern Poetry Notebook). Magazines in those days weren't as rigid as they are these days. They were open to all kinds of things. The same is true of the arts sections of newspapers. There were lots of talented writers around.

ONDA: So it wasn't just the magazines, it was also the quality of the writers.

YOSHIMASU: Part of it was that journalism in Japan was still a youthful field. However, Takiguchi never wrote for the newspapers. As far as I know, he only wrote one piece—about Surrealism. He kept his distance and played the role of a sort of paterfamilias to the avant-garde artists. Around this time there was a big to-do over Akasegawa Genpei's trial for printing fake thousand-yen bills, and Takiguchi acted as his special counsel. In this crucial case, in which Akasegawa was being prosecuted for what they were calling an antisocial act, Takiguchi stepped forward and offered his support. Whenever there was something of importance going on, Takiguchi was sure to be there.

ONDA: What kind of engagement was there with American culture during this period?

YOSHIMASU: The name on everyone's lips, the mythic figure, was Marcel Duchamp, and John Cage was seen as part of the same sphere. Then a few years later, in the latter half of the sixties, there was the poetry/jazz movement. Takiguchi was not involved in that. Rather, when it comes to jazz, it was the people at the literary magazine *VOU*—Shimizu Toshihiko, Okunari Tatsu, Shiraishi Kazuko. Then, I think it was in 1971 that Jonas Mekas's film *Reminiscences of a Journey to Lithuania* came to Japan. I can still clearly remember the impact of that. The artist Nobuyoshi Araki appeared around that time, and I think the filmmaker Iimura Takahiko was on the scene earlier than that. These people really shook things up, I think.

ONDA: In those days, I think most people in Japan, aside from the kind of prominent people you mentioned, had limited access to information about what was going on in America. Not many people saw the films of Mekas, viewed the paintings and performances of Rauschenberg, heard the poems of Ginsberg, and kept abreast of the New York underground. Do you think people were aware of the scene in New York?

YOSHIMASU: I myself was not.

ONDA: So you didn't have the overall picture, but you had glimpses—through Mekas and Ginsberg, for example—is that correct?

YOSHIMASU: That's about right. Much, much later, in the late eighties, I attended a party held by Mekas in New York, and Ginsberg was there, and I finally started to connect the dots. I guess I was slow to pick up on things.

ONDA: The reason I ask is that it seems that Takiguchi Shuzo and the Japanese intelligentsia brought an enormous amount of information about Surrealism and

Gozo Yoshimasu at a performance.
Photo by François Lespiau.

French culture into Japan, but that when it came to the New York scene, the overall level of awareness in Japan was pretty low.

YOSHIMASU: You've got a point there, Onda-san, but on the other hand, if you were interviewing someone else you might get an entirely different picture of what was going on. For example, if you asked Kosugi Takehisa, Shinohara Ushio, or Matsumoto Toshio. In 1964 Tono Yoshiaki published a book called *Gendai Bijutsu* (Contemporary Art). He had traveled to the U.S. and gone around seeing the contemporary art scene close up, in New York especially, and turned what he saw into this book. That was really a momentous event, one that greatly elevated what you call the level of awareness of the American scene. For me, in particular, it certainly did.

ONDA: That's interesting. All this information trickled into Japan from here and there, bit by bit.

YOSHIMASU: One very influential aspect of American culture was jazz. At the Pit Inn in Shinjuku, Yamashita Yosuke performed alongside Elvin Jones, who had been arrested for drugs and couldn't go back to the U.S. A Butoh dance troupe danced at some of the performances, and people started doing things that combined poetry and jazz.

ONDA: And wasn't it around that time that you started reading your poetry aloud with live jazz accompaniment? What exactly led up to that?

YOSHIMASU: It was at the Pit Inn in Shinjuku, with Suwa Yu running the show. The person who originally proposed the idea was Soejima Teruto, the most radical jazz critic at the time. Around 1968 he suggested combining poetry with free jazz, and the events got started in the New Jazz Hall on the second floor of the Pit Inn, which was really just a glorified broom closet. There were some performers who are now legendary—Abe Kaoru, Takayanagi Masayuki, Oki Itaru—but the audience generally numbered about two or three, with five or six people performing.

The well-known actor Tonoyama Taiji often attended, and one time when we were doing a radio program together, he said, "You know, there are five or six of you guys performing, but the audience consists of me and about one other person." They were doing a kind of very explosive experimental jazz. Then I was invited by Soejima to work with a jazz combo, and I dove right into the jazz performance and recited a poem called "*Kodai Tenmondai*" (Ancient Astronomical Observatory).

ONDA: What style did you adopt when reciting the poetry?

YOSHIMASU: Well, the music is frenetic, right? It's so noisy you can't make out what they're playing. So my voice builds up to a scream. When I was working with musicians, I felt I had crossed over from the audience's side to the performers' side, and I could do anything I felt like. It was an amazing feeling.

ONDA: You must have gone outside the bounds of merely reciting poetry.

YOSHIMASU: That's right. I felt like I, myself, was an instrument. I remember some of the jazz people raising their eyebrows and saying, "Man, what kind of vocalist is this?"

ONDA: Did you perform anywhere besides the Pit Inn?

YOSHIMASU: A long time afterward we performed at a little theater dedicated to puppet plays, called Pulcinella, on the third floor of a small building across the street from the Tokyu Department Store's flagship store in Shibuya. That was through Suwa-san as well. We did a lot of performances combining jazz and poetry readings there. Around 1972 we also did an avant-garde show of jazz and poetry at the Ikebukuro branch of Parco.

ONDA: How did you start collaborating with the guitarist Takayanagi Masayuki?

YOSHIMASU: Soejima Teruto introduced me to the bassist Midorikawa Keiki, and we had a great partnership for quite a long time. Midorikawa was associated with two more experienced musicians, one of whom was Takayanagi Masayuki, the guitarist. The other was the percussionist Togashi Masahiko. I participated in a session, along with Midorikawa and Takayanagi. There were also sessions where I worked with Midorikawa and Togashi, but it was with Takayanagi that I got into some of the farthest-out stuff. When performing with him, to be honest, I was at a loss sometimes. The volume was so incredibly loud, you know? I couldn't even hear what was going on. It went beyond what a guy like Haino Keiji was doing, Takayanagi was intentionally going overboard. [*Laughs.*]

ONDA: Despite the decibel level, he wanted to add a poetry reading on top of it? [*Laughs.*]

YOSHIMASU: When the sound was well balanced, you could hear the recitation as one more sound source, but a lot of times it was just lost in the chaos.

ONDA: Do you have any recordings made during that period? I know a CD of Takayanagi Masayuki and Midorikawa Keiki's Shibito (Dead Person) was released, but is there anything else?

YOSHIMASU: Just like you, I have tons of old tapes lying around. My apartment is knee-deep in hundreds of cassettes.

ONDA: All right, I'll have to come over and poke around.

YOSHIMASU: I've got so many old tapes, you won't believe it. [*Laughs.*]

ONDA: Were there lots of poets collaborating with jazz musicians, and did the trend spread throughout the poetry world? Or was it just you and your associates?

YOSHIMASU: My personal impression is that it did not, by any means, spread throughout the poetry world. The world of literature is by nature extremely conservative, and that of poetry is even more so. They scorn and deride any attempt at showmanship, like mixing in singing or anything playful. There's no way that collaborating with musicians would ever be a mainstream thing. In fact, a lot of people still have a reflexive dislike of poetry's being read, period.

ONDA: I see. Was there anyone besides you who was involved in it, then?

YOSHIMASU: Well, the person who pioneered it was Shiraishi Kazuko. In the early days Shiraishi worked with Tomioka Taeko. Shiraishi-san had had a really rough time of it, having been born in Canada as well as being a woman, and so she was a rabble-rouser from the core.

ONDA: A few years ago I saw Shiraishi Kazuko performing opposite Oki Itaru at the Bowery Poetry Room. She radiated an incredibly powerful aura. Just her sheer eccentricity…. She obviously doesn't give much credence to authority.

YOSHIMASU: She certainly doesn't. Tomioka Taeko went over to the literary world, but by contrast, Shiraishi Kazuko has insisted on sticking to the same path for all these years. Most poets, if left to their own devices, will end up moving in purely literary circles or being swallowed up by academia.

ONDA: Yes, there's not a lot of money in poetry. [*Laughs.*]

YOSHIMASU: There sure isn't. [*Laughs.*] These people are facing financial issues. After all, you can't survive on stubbornness alone.

ONDA: In which years were you performing with jazz musicians?

YOSHIMASU: Hmm, when was it? I guess for about fifteen years starting in 1968. However, as a matter of fact, I don't like reciting poetry. Essentially, I prefer writing it. What I've kept throughout, as an underlying philosophy, is the quest to reclaim the poetry that I believe lies at the root of all performing arts. It's not just a mere poetry reading. To the audience I may have looked enthusiastic but, in fact, I always felt a bit weak in the knees when I was doing it.

ONDA: Personally, you would rather have focused on writing poetry and kept the performances as a sort of sideline.

YOSHIMASU: That's right. I've been consistently fascinated with the materiality of language, but when it comes to getting onstage or performing with language, I've always had my doubts and I still do. It might sound like a contradiction, but…

ONDA: I suppose when one is pursuing the direction you've been pursuing —deconstructing the language that poetry is built from—then performance is one way of expressing those ideas, although writing itself is always at the base of things.

YOSHIMASU: "Deconstructing" makes it sound like a deliberate act of the intellect, but I think the motivation for performing comes from somewhere deeper, from the fundamental creative instinct. I think it's clear to see, looking through the poetry books that I've published. In the mid-seventies the publisher Kawade Shobo approached me about releasing a collection of my complete works. I was still young, and releasing my complete works was something I'd never even dreamed of. I wasn't ready to be placed in that position, you know? And so I frantically went about writing a three-part work called Neppu (Devil's Wind), which was a thousand lines long, for the magazine Umi (Sea). I incorporated marks, like dots, lines, and brackets, into the text, so that it would be impossible to read aloud. But I ended up reciting it anyway. For me, reading aloud is a terrifying thing, and so I memorize the poem beforehand. But when you memorize it and recite it, it becomes just like the lyrics to a pop song or something. You have to demolish it somehow. I know this instinctively, and the way I do this is to write the demolition into the poem itself.

Yoshimasu Gozo. *Naked Writing* "八戸 *Hachinohe*". 2010. Courtesy of the artist © 2014 the artist.

ONDA: To me, the way those punctuation marks are used looks like a form of breathing.

YOSHIMASU: That's right. It's also a form of breathing. Sitting down to write a thousand lines is tough, right? And so you skip some lines, ha-ha-ha. But you have to make it look like the spaces are pauses to take breaths.

ONDA: And so the blank lines are part of the text. There are the words, and then they're interspersed by …

YOSHIMASU: Silences.

ONDA: I see. You wove silences into the text.

YOSHIMASU: Usually, they count only the actual lines of text, but here, there were punctuation marks and spaces and things, and I got paid for those lines as well. [*Laughs.*]

ONDA: A technique you struck on when you were under duress.

YOSHIMASU: Around that time I was making repeated trips to Mt. Osore [Mt. Fear, in northern Japan, said to be the "gateway to the other world"— *Translator's Note*]. It was a trek; the Tohoku Expressway was still only half completed then. The first time I went was when an American poet named Thomas Fitzsimmons and his wife were staying with me, and I thought it'd be a kick to show them Mt. Osore. But I had a shock there.

ONDA: What gave you a shock?

YOSHIMASU: It really is an intermediate zone between worlds.

ONDA: What did you do there? Did you see a shaman, or a medium?

YOSHIMASU: Yes, we did. The mediums are pariahs; they're not allowed on the premises of the main temple at Mt. Osore. They lay down straw mats off to the side of the temple and sit on them. Not one of them is like another. And they're all blind, you know. So we sat down next to them, and I was thrilled with the spectacle. What could be more dramatic? They're supposedly possessed, with the dead speaking through them, but it's all a bit fishy. [*Laughs.*]

ONDA: What they're saying couldn't strictly be called "words," right?

YOSHIMASU: That's right. It's not words so much as tones and melodies. You feel a really incredible vibration from them. In kabuki, there are scenes in which female characters express powerful emotions in a chanted lyrical monologue called kudoki, and it sounds something like that. It's just nonsense, like, "I see the tree of heaven, it bears the fruit of the sacred name of the Buddha, ohhh" Some of them are really good at it, others are not so good. [*Laughs.*] The not-so-good ones are merely prosaic. The great ones are superstars. I brought along a tape recorder, sat down next to an old woman who struck my fancy, and recorded her, though I couldn't comprehend the Tohoku dialect. Sony had released a portable tape recorder in 1974 or 1975, and to be able to walk around with a tape recorder felt revolutionary. I brought the tape I had recorded to a local hot spring inn and got one of the maids there to interpret it for me. That was really something. "My name is blah blah blah, I went off to war but I came back empty-handed, and then" She spoke in a thick Tohoku accent and used the word *hettei*, which I couldn't understand. When I asked what "*hettei*" meant, she told me—*Heitai, heitai*—a soldier.

ONDA: So you see this medium, and she's channeling some spirit from the "other world." What were you hoping to get out of this experience?

Yoshimasu Gozo. *Naked Writing* "光の棘 *Hikari no Toge*". 2007. Courtesy of the artist © 2014 the artist.

YOSHIMASU: When the spirit was coming on, she rattled this instrument like a kind of net made of seashells. It was a rudimentary thing, but she was able to produce a real aura of drama with this makeshift instrument and the sutra she was chanting. It really shook me up. After that, when I watched something like Hijikata Tatsumi's Butoh dance performance in Ikebukuro, I'd get bored with it. It paled in comparison to the medium's performance, I realized. She was the real deal.

ONDA: You mean Butoh is just too polished and civilized.

YOSHIMASU: Once what someone is doing gets called art, it immediately becomes merely acting, a mere transmission of information. I realized that this kind of thing was going nowhere fast. And so I started traveling to Mt. Osore regularly and making tape recordings. Then I'd hole up at a hot spring inn there in Aomori Prefecture and go over them with a fine-tooth comb. I remember a moment when I suddenly understood what she was saying in her thick Tohoku accent: "I'm cursed with bad luck." It was a revelation. I spent a long time going through the tapes like that.

ONDA: Did you make transcripts of them?

YOSHIMASU: I did. I still have them all. I transcribed them for dear life. I guess writing is in my blood. [*Laughs.*] I published them in a magazine called *Bungakkai* (Literary World).

ONDA: There's a phrase *geijutsu no ibuki*, literally, the "breath of art," but what this "breath" means to me is vibration. Something that is not yet concrete, but still seeking form. I guess you felt this vibration directly from the mediums.

YOSHIMASU: It was fantastic. It almost had the resonance of a circus scene in a Fellini film.

ONDA: What sort of influence did it have on the form your poetry recitation performances took?

YOSHIMASU: The northern Siberian shamans do everything themselves, just like the mediums. They strum instruments, suspend lamps from their necks; they create all these kind of oscillating circuits. They're all abuzz like human insects. I think I'm trying to get to a similar place—before I start reading a text, I always think about what noises I'm going to make, how I'm going to sit, and so on, taking the whole process as one of connecting with something. When I traveled to Mt. Osore and sat with the mediums,

I was trying to absorb the atmosphere they created with the instruments and noises they made so that I could do a similar thing myself. It took me thirty or forty years to realize this. I've been wounded by comments that compared me to a shaman and so forth, but that was really just "tears of ignorance" on my part.

ONDA: The work that you've done over half a century, which in narrow terms you could call poetry, and in broad terms you could call a revolt against the Japanese cultural establishment—all these attempts to head off in entirely new directions in writing or performances and so forth—have you been subject to prejudice because of these?

YOSHIMASU: Maybe so. I certainly have a deep-rooted instinct toward provocation, or rebellion. And, as I've realized in the course of this conversation we're having, I have a deep respect for "the materiality of language" and innate "ignorance." Those lie at the root of my poetry. Or perhaps it's anger.

ONDA: From what I've heard from you today, it seems like the cultural climate of Japan in the sixties and seventies was one in which anger like that was accepted. Like culturally, there was a fundamental openness to anything, including the kind of new things you learned from Takiguchi. Or to put it another way, the culture at the time was deeply anti-authoritarian. My impression is that you were lucky to spend your younger days, when you were learning and developing creatively, in a climate of antiestablishment rebellion.

YOSHIMASU: You're right. For fifty years my hand has never stopped writing poetry. I've published more than twenty books of poetry. Looking back on it now, there must have been a reason for it. No matter how tough things got, I never stopped writing. The performances may have been a way of replenishing my energy to write more poems. But now, even today, I write poems so that they can't be read aloud. For example, "Rasenka" (Spiral Song) is impossible to read aloud. One thing's for sure: something I start out writing with the intention of reading aloud will never be any good. [*Laughs.*]

ONDA: Excuse me for changing the subject, but in the 1970s you went to America to take part in the Writers' Workshop at the University of Iowa, didn't you? Were you teaching there?

YOSHIMASU: No, no. They just invite writers from all over the world and provide them with an ideal climate for writing. For seven months, from autumn through the following spring, you're given no obligations whatsoever.

ONDA: Did your direct encounters with American culture have an impact on your work?

YOSHIMASU: What came over me then—and I think this is something that's still happening to me today—was not an urge to try to learn English and immerse myself in American culture, but rather something was eating away at the language I use instinctively in everyday situations. I wondered, why am I making no effort to learn English? It was because another language, Japanese, which I use for creative expression, was getting in the way. And so I had a bit of a nervous breakdown, and this withering away of language became my jumping-off place. That was quite an important turn of events.

ONDA: You didn't attempt to speak English or to enrich your Japanese, but rather took steps toward making yourself wordless and seeing where that led you creatively.

YOSHIMASU: Looking back on it now, that was true silence. True quiet, something on the scale of the entire universe. You could also call it poetry.

ONDA: While dwelling in the world of poetry, which is one of words, you were attempting to use something other than words in order to transcend words.

YOSHIMASU: That's right. It was constant torment, that's for sure. The torment comes and goes in waves. You ask yourself questions, like, "Is it just that I have no talent?" and then answer them yourself. After that I went to Michigan and had the same experience, and then I went to São Paulo and had the same experience again. And then I realized there were cracks forming in the very foundations of my command of language and it was withering of its own accord. What made it even more painful was that I was writing through all of this.

ONDA: And from there, you went in a new creative direction.

YOSHIMASU: Right. And I finally arrived at an awareness of the act of "causing language to wither" and came up with the phrase for it. It's an exaggeration to say it took half a century, but it did take forty years or so.

ONDA: Which book of poetry did you write around that time?

YOSHIMASU: What I wrote after returning to Japan were extremely chaotic works, *Okoku* (Kingdom) and *Waga akuma barai* (My Exorcism). I wrote these despite the state I was in.

ONDA: You kind of felt your way along when you were writing them.

YOSHIMASU: Well, I always do that. I'm not led by my intellect. It's something more primal. I'm driven by the impulse to wrest something from the words I encounter.

ONDA: Where do you think this impulse comes from?

YOSHIMASU: I wonder where. It doesn't come from knowledge or experience. I really think I'm similar to one of those blind old mediums babbling mystical nonsense about the Buddha.

ONDA: I don't think there's anything so mysterious about the mediums' behavior, though. The mediums have always been oppressed, downtrodden. From this they've acquired some special capabilities. They have certain techniques for transmitting the world's vibrations.

YOSHIMASU: Yes, you said it right there. Transmitting the world's vibrations —vibrations that reach into and touch every area of a person's life. The mediums are all gone now; their tradition has died out. But the amazing thing for me is that, if it hadn't been for those encounters, my life would really have been a dull one.

ONDA: Finally, I'd like to ask you about Takemitsu Toru. Takemitsu had a really open mind, just like Takiguchi Shuzo. He was a contemporary composer, but in addition to composing film soundtracks and so forth, he was a prolific writer. And he served as director of the Music Today festival, which was held from 1973 to 1992. He brought all sorts of composers from overseas and constantly breathed life into Japanese culture. He also introduced a lot of Japanese composers to audiences outside Japan. He was a cultural ambassador and a cultural icon. I feel he has something in common with you, as you both refuse to be pigeonholed, but instead dismantle categories, destroy them, clear space away so that new forms of creative expression can blossom. Have you had any interactions with Takemitsu?

YOSHIMASU: Yes, we had a dialogue that's transcribed in the Chikuma Bunko publication *Takemitsu Toru taidan sen: Shigoto no yume, yume no shigoto* (Selected Dialogues of Takemitsu Toru: The Dream of Working, the Work of Dreaming). Among Takiguchi's protégés, he had the greatest mind. And he was an odd guy, with no higher education.

ONDA: That's right, he never went to high school, much less to university.

YOSHIMASU: Right, and he came of age right after the war ended. At one time he was working part-time at Tokyo Tsushin Kogyo (Tokyo Telecommunications Engineering Corporation), the predecessor of Sony. At that time "Sony" was just the company's logo or nickname, or something like that. At first it was just a glorified version of one of these small local factories. Then along came tape recording and magnetic wire recording, and suddenly all kinds of sounds were being recorded. This means that Takemitsu was there right at the dawn of tape recording in Japan. He was a nuts-and-bolts guy, but then, when he went under the tutelage of a Surrealist intellectual like Takiguchi, his talent blossomed splendidly.

ONDA: I heard an interesting story from Otomo Yoshihide. He said that when Takemitsu heard the first film soundtrack that he [Otomo] had composed, for *The Blue Kite*, Takemitsu called him up and said he wanted to meet. He must have felt a sense of kinship with me, Otomo supposed. Then when they actually met, what Takemitsu said was, "You know, I was using turntables as an instrument first, man." [*Laughs.*]

YOSHIMASU: So Takemitsu had that side to him, huh? [*Laughs.*]

ONDA: He did feel a sense of kinship with Otomo, but out of that, perhaps, came a sense of rivalry. From what you told me just now about tape recorders, rather than having a formal musical education, Takemitsu got into music from the standpoint of breaking it down into component parts, but he ended up as a respected and acclaimed contemporary composer. However, he also composed a lot of film soundtracks and even pop songs, and he never lost his ability to relate to ordinary people.

YOSHIMASU: Part of it has to do with timing, I suppose. If Takemitsu had been born just five years later, he might not have experienced the postwar Allied Occupation era, when Sony grew out of a small neighborhood factory, in the same way. It seems like destiny.

ONDA: Destiny defined by history, you could say.

YOSHIMASU: I sent him books of poetry on several occasions and got letters back from him. That was really a wonderful thing. Like Takiguchi, when Takemitsu had a direct personal connection with someone, he was very good at expressing this closeness and comradeship.

ONDA: You were in-your-face and anti-authoritarian, whereas Takemitsu was more mild mannered. However, you shared a similar mentality, you both brought a lot of people together, and you also both bent and obliterated boundaries between genres. He talked constantly about his lack of formal musical education not really because it gave him an inferiority complex, but more as a badge of rebellious authenticity. If you look through all of his writings, you find him making statements to this effect throughout.

YOSHIMASU: You're right on target there. Speaking of Takemitsu, during performances I sometimes dangle this rock called *sanukite* from my mouth. Takemitsu struck this same material, sanukite, to make the sound of the wind blowing in scenes featuring the snow-woman ghost in Kobayashi Masaki's 1956 film adaptation of Lafcadio Hearn's *Kwaidan*. It's a *musique concrète* technique, but it's an example of how imaginative he was as a composer. That really drew me to him.

ONDA: Where do they mine sanukite?

YOSHIMASU: It was originally mined in the Sanuki region on the island of Shikoku. That's where the name *sanukite* comes from. There's an undersea land bridge from there to Nara and the Kawachi region on the other side of the Seto Inland Sea, in Honshu, and it's found there, too.

ONDA: Where did you get your sanukite from?

YOSHIMASU: In the Sanuki region, they call it a "ding-ding rock" or something like that —because of the sound it makes—and sell it at souvenir shops. I got some and carried it around with me. When I was teaching at the university, when I was talking about Takemitsu Toru, I told the students about sanukite. Then at some point, I went from teaching about it in the classroom to doing it myself. The sound Takemitsu produced was processed in a *musique concrète* manner, and so it's a little different from the natural sound of sanukite, and I wanted to hear what the original sounded like. Also, I just like beating on rocks and things, and so that's another reason for it. If you want to beautify it, you can call it an extension of Takemitsu Toru or an homage to his work, but there's both more and less to it.

ONDA: Right, there are more factors involved. In any case, when you channel somebody or something, you're not just mimicking it, you're also taking steps toward grasping its essence.

YOSHIMASU: We certainly talked about a lot of heavy stuff today. It was fun, but even more than that, it was heavy.

ONDA: Some of this stuff is kind of scary, isn't it? [*Laughs.*] But artistic expression, creating something, is always connecting to something larger.

YOSHIMASU: After talking about all of these things, I get the sense that I've already fulfilled some small part of my lifelong dream. Thank you so much.

ONDA: Thank you.

———

: TRANSLATED BY COLIN SMITH

Originally published in Japanese and English online: *Notes on Modern and Contemporary Art around the Globe* on the digital platform of C-MAP, MOMA's global research initiative, Feb. 2014.

Interview by Lee Yew Leong

———

LYL: How did you come to write in this style?

GY: When I began writing poetry in the 1960s, I incurred the displeasure of other poets for the frequent use of unconventional notation such as exclamation points or dots in my work. Though I got used to the fact that my style does not sit well with traditionalists, it has taken fifty years for me to become conscious of what I've been doing exactly. What I try to do is crack open the conventional composition of the language to reveal the innate imperfections underneath the exterior of elegance. In setting out to create flawed pieces, I try to establish an alternative ideal of poetry, by which such pieces find acceptance. I try to enter into this parallel world via my work.

I used to call my writing "naked writing," or "magic note" or "*Tsukuda* newspaper." This style naturally evolved from my habit of using tiny side notes and rubi, which, for me anyway, have an uncertain noise about them. Over time, they took over the page, and my writing settled itself into this form, as a corollary of that. But there is another reason for my writing being like this, too. Without realizing it, I guess it was a way of also protesting against the constraints of publication: maximum word count, deadlines, etc. So I started handing out limited edition copies of my handwritten drafts at poetry readings and *gozoCiné* video screenings as a sort of *omiyage*—a souvenir of the occasion. This has become one of the ways I "publish" my writing.

LYL: Why do you use various colors in your writings?

GY: It's a *sho* that I've simply developed for myself, the methodology of which was the subject of my recent discussion with the Japanese calligrapher Kyuyo Ishikawa. It's also a homage to artists such as P. Klee, Cezanne, van Gogh, and W. Blake. John Cage is the other artist I give a tip of the hat to through this writing.

LYL: What do the different colors mean?

GY: They are there to provide a *frisson* to the textual arrangement; they also function as subtle stirrers of the subconscious and memory. Importantly and meaningfully, the manner in which I change the pens is impressionistic. In choosing a pen, I sometimes

pick the very yellow or green that van Gogh himself chose, in order to try to understand the color he used. I predict that I will radicalize the canvas, as Klee has probably done.

LYL: What do you hope to do with this kind of writing?

GY: I don't see this as only *écriture*. The *Uchu no Shitakaze*, or cosmic wind: that's what I am attempting to convey through my writing.

Thank you for your questions. I hope that your journal will become a treasure of Singapore.

———

: TRANSLATED FROM THE JAPANESE BY SAYURI OKAMOTO

First published in *Asymptote*.

Post-3-11: Believing and Doubting Poetry

Interview in *Asahi Shimbun* by Akada Yasukazu, February 24, 2012.

The Great Eastern Japan Earthquake rocked the very axis of the world of poetry, one comprised entirely of words. How do poets confront the post-quake world, and how do they position their own work and roles within it? We now pose the question, "What is poetry?" to Yoshimasu Gozo as a representative of modern Japanese poetry.

Yoshimasu Gozo: Smashing words to bits, speaking in a new voice:

Last year, I visited Rikuzen Takata City in Iwate Prefecture. The blue sign from a convenience store, tatami mats, New Year's Cards were scattered about. Bulldozers' giant hands were raking out the rubble. At that time, those were unnamable things, things you can neither film nor express. You simply have to hang your head. I heard their voice.

Many people simply find their mouths clenched shut with the pain of deep experiences that can't be put into everyday words. There are voices that cannot arrive via television images or scholarly remarks.

The Irish poet Yeats said, "In dreams begins the responsibility to write poetry." When I listened to a young student who was struck by the tsunami and lived to tell tale, I too thought that I must take responsibility, spend a long time, and touch that child's voice within a dream. I felt I could actually see the table in the child's room whispering to the child, "Let's run away together!"

Paul Valéry called poetry a "hesitation between sound and meaning." Somewhere in the depths lurk the spirits of sounds. In turn, various lights draw near. Some presaged by a shimmering, sweet smell, others as surprise attacks. The faint voices of the spirits I make into sound; I pursue the new meanings that emerge next to the sounds, blending sound with meaning.

Until I reach that point, I have to stare at that desperate, desolate landscape time and again, circling the underworld. Smashing my own words to bits, I proffer totally new voices. Poetry is that labor done even when labeled unintelligible.

———

: TRANSLATED BY JORDAN A. YAMAJI SMITH

GOZO YOSHIMASU is one of the most prominent figures in Japanese contemporary literature and art. Born in Tokyo in 1939, he started writing poetry in the 1960s, while still reading Japanese Literature at Keio University. Over a career that has spanned 50 years, most of which he has devoted to poetry, he has also created artwork of various media ranging from photography to video to spoken performances. Winner of several prizes including the Takami Jun Prize (for *Ogon Shihen/Golden verbs*), the Rekitei Prize (for *Neppu, a thousand steps/ Devil's Wind, a thousand steps*), the Purple Ribbon Medal, and the Mainichi Geijutsu Prize (for *omote-gami*, a photography book), Yoshimasu has taught in many universities worldwide including University of Southern California, University of Lyon, and Waseda University. At the moment he devotes his time to creating *GozoCiné* (video works) and to the publication of both books and limited edition copies of Naked Writing.

FORREST GANDER is a writer and translator with degrees in geology and English literature. His book *Core Samples from the World* was a finalist for the Pulitzer Prize and the National Book Critics Circle Award. Among his many translations are *Fungus Skull Eye Wing: Selected Poems of Alfonso D'Aquino* and, with Kyoko Yoshida, *Spectacle & Pigsty: Poems by Kiwao Nomura*. Gander's latest book is *The Trace: A Novel*.